STEP-BY-STEP GUIDE TO
PAINTING REALISTIC
WATERCOLORS

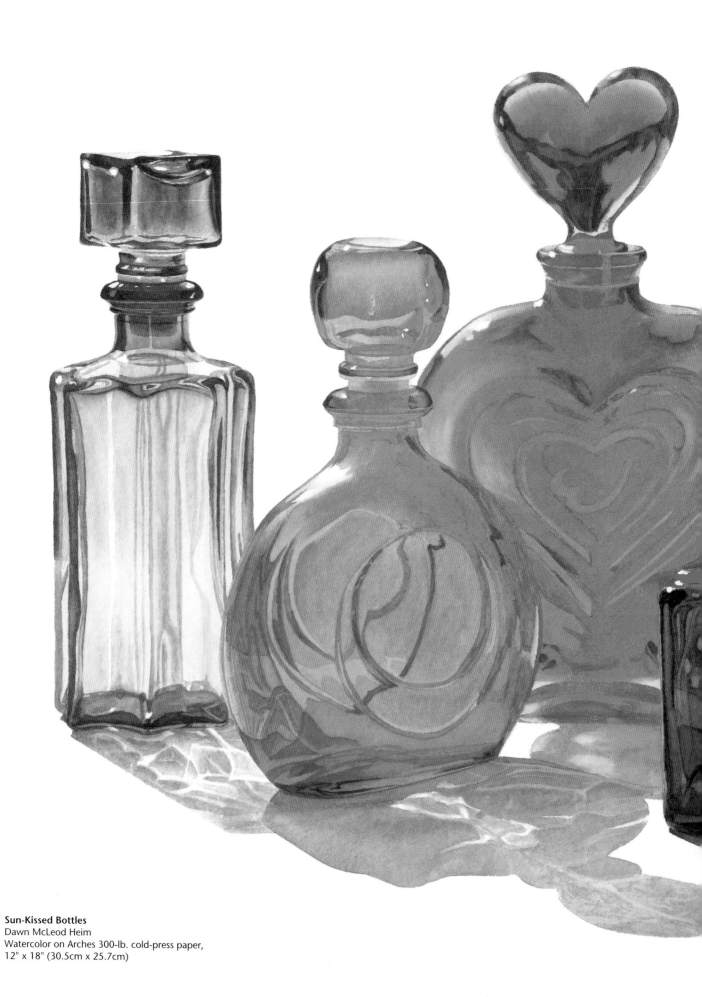

Sun-Kissed Bottles
Dawn McLeod Heim
Watercolor on Arches 300-lb. cold-press paper,
12" x 18" (30.5cm x 25.7cm)

STEP-BY-STEP

GUIDE TO

PAINTING REALISTIC WATER COLORS

Dawn McLeod Heim

NORTH LIGHT BOOKS
Cincinnati, Ohio

ABOUT THE AUTHOR

Born and raised in Northern California, Dawn McLeod Heim is a popular teacher and award-winning watercolorist. A full member of the California Watercolor Association, she was a finalist in *The Artist's Magazine* 1995 Cover Competition, and is featured in *Splash 4: The Splendor of Light* (North Light Books, 1996).

Dawn's work can be seen at Thrasher's Gallery in San Carlos, California, where people are drawn to her realistic style of painting, with its ease of composition, sensitive handling of color and clarity of vision. Her paintings are in private collections throughout the United States and in Europe.

She teaches watercolor classes to about 50 adults on an ongoing basis, and conducts workshops for beginning students at her own studio, The Watercolor Rose, in Dublin, California. For more information, contact her at P.O. Box 2593, Dublin, CA 94568.

Step-by-Step Guide to Painting Realistic Watercolors. Copyright © 1997 by Dawn McLeod Heim. Manufactured in China. All rights reserved. No part of this book may be reproduced in any form or by any electronic or mechanical means including information storage and retrieval systems without permission in writing from the publisher, except by a reviewer, who may quote brief passages in a review. Published by North Light Books, an imprint of F&W Publications, Inc., 1507 Dana Avenue, Cincinnati, Ohio 45207. (800)289-0963. First paperback edition 2000.

Other fine North Light Books are available from your local bookstore, art supply store or direct from the publisher.

04 03 02 01 00 5 4 3 2 1

Library of Congress has catalogued hard copy edition as follows:

Heim, Dawn McLeod.
 Step-by-step guide to painting realistic watercolors
Dawn McLeod Heim. – 1st ed.
 p. cm.
 Includes index.
 ISBN 0-89134-714-3 (hard cover)
 1. Watercolor painting–Technique. I. Title.
ND2420.H45 1997 96-46687
751.42′2–dc20 CIP
ISBN 1-58180-054-1 (pbk: alk. paper)

Edited by Kathy Kipp
Designed by Angela Lennert Wilcox

METRIC CONVERSION CHART

TO CONVERT	TO	MULTIPLY BY
Inches	Centimeters	2.54
Centimeters	Inches	0.4
Feet	Centimeters	30.5
Centimeters	Feet	0.03
Yards	Meters	0.9
Meters	Yards	1.1
Sq. Inches	Sq. Centimeters	6.45
Sq. Centimeters	Sq. Inches	0.16
Sq. Feet	Sq. Meters	0.09
Sq. Meters	Sq. Feet	10.8
Sq. Yards	Sq. Meters	0.8
Sq. Meters	Sq. Yards	1.2
Pounds	Kilograms	0.45
Kilograms	Pounds	2.2

DEDICATION

I would like to dedicate this book to my children, Crystal and Josh—whose comment for the last year has been, "When are you going to be done with that book?"—for forfeiting a year's worth of quality time together so that I could share with others what I enjoy most. To my mother, Thelma McLeod, who resides in England, and has been able to share my accomplishments and dreams only through letters and photographs. In memory of my grandmother and my father, who closely followed my art career, and did not live long enough to see this achievement. Most importantly, I would like to dedicate this book to all my wonderful students. Without their inspiration and input in helping me fine-tune my method of teaching, this book would not have been possible.

ACKNOWLEDGMENTS

This part of the book has always reminded me of an actor's acceptance speech after winning an Academy Award. I now know the difficulty one faces when narrowing the list of people to thank. I want to thank each and every person who touched my life, in a big way or small, during the time it took to reach this achievement. But there is only enough time or space to mention the key people involved. May all of you who have played smaller roles during this time know that the thanks are just as heartfelt.

First and foremost, to all the wonderful people at North Light Books who played a part in putting this book together. To editors Rachel Wolf and Kathy Kipp, two of the nicest people a person could ever have the opportunity to work with. Plus an extra-special note of thanks to Kathy for all the wonderfully inspiring and uplifting phone conversations, and for always being available to answer my questions.

To my two closest and dearest friends, Linda Ono and Deborah Burgess-Uneberg, who kept putting my life back into perspective with their endless amounts of encouragement and support. And for reassuring me that the light at the end of the tunnel was not an oncoming train.

To Rae Harrison and Carole Hilton. Not only are they two dear friends, but as the first students I privately taught, they were the driving force behind my teaching watercolor techniques to others.

To Marilyn Jessup, a student and a friend, who saw the potential of making a book based on class projects and encouraged me to write to North Light Books.

To another student and friend, Judy Beyer, who unselfishly donated so much of her time to help keep me organized so that I could keep up with my ongoing classes, who proofread my final draft and assisted me with the photography.

To John McClure at Copy Quick for the excellent job he did on all the ink printings of my drawings.

To Jim Ferreira for contributing his expertise to the final photography of the finished projects in this book.

To Penny Soto for introducing me to watercolor.

To Carol Wilson for giving me the opportunity to teach in her shop.

Table of Contents

P R O J E C T S

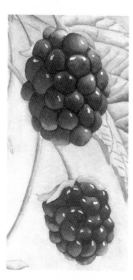

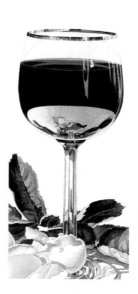

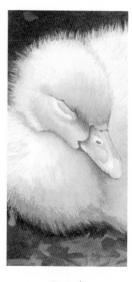

1
Stained
Glass Iris

PAGE 32

2
Truffle and
Notecard

PAGE 40

3
Cluster
of Berries

PAGE 48

4
Wine Glass
and Rose

PAGE 56

5
Snuggling
Ducklings

PAGE 66

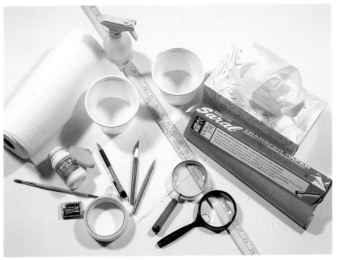

All the supplies you'll need are listed on pages 10-12.

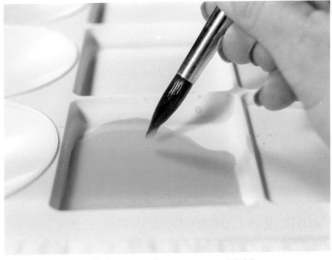

Basic watercolor techniques are shown on pages 13-15.

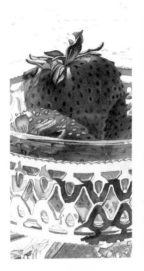

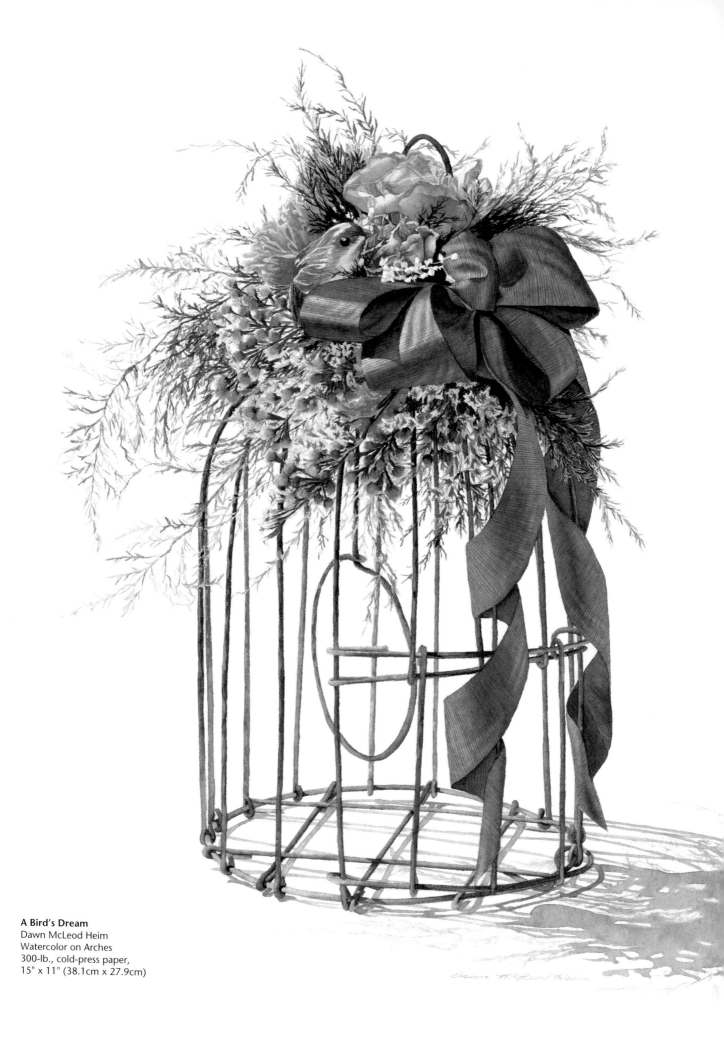

A Bird's Dream
Dawn McLeod Heim
Watercolor on Arches
300-lb., cold-press paper,
15" x 11" (38.1cm x 27.9cm)

Introduction

There are many pleasures in life, but one pleasure I have found truly rewarding is teaching watercolor techniques to those who want to learn, especially to those who feel that painting in watercolor is something they are unable to do.

When I first began teaching, the students in my class ranged from beginners to award winners. For my students to fully understand my painting process, I would paint an entire painting first, then break it down into individual steps with lessons. I would give each student a copy of the same lined drawing I was using so they could clearly see which areas we would be painting. I would demonstrate every step and allow the students time to paint along with me.

After answering their questions on what inspired me to paint the subject matter, why I chose the colors I used, etc., I would walk around to see how they were doing. As I walked around, I noticed that some students were having difficulty gauging the amount of pigment to use when mixing their colors, while others had trouble seeing and understanding values. And the students who were new to watercolor were lost because they hadn't yet learned the basics.

I decided the best thing to do was to teach those who were new to watercolor separately, starting with the basics. I needed to design a way of teaching that would accommodate their needs, boost their confidence, and enable them to produce artwork they could be immediately proud of.

I have put this method of teaching to the test over the years, and the results have been remarkable. Not only have my students sharpened their skills and techniques, but they have also gained the confidence in themselves to create artwork on their own. They are now selling their paintings, entering shows and winning awards! So I know this method of teaching does work.

In this book, I will give you the knowledge to utilize the skills you already have, which may range from few to many, and combine them with easy lessons and techniques to produce ten beautiful paintings you can be proud of. Each of the ten projects, in addition to teaching you all about the basic watercolor techniques, lists what paints you will need, what size brushes, what type of paper, and all other supplies. I also provide you with very detailed drawings you can trace, the colors that you will need to mix, as well as their values. Each step has a color bar showing you which colors you will be using for that step, complete and clear step-by-step instructions, sample artwork showing you exactly what areas are to be painted, and a photograph showing the painting in progress.

At the end of each project, I teach you how to critique your own work and how to solve common problems we all face while painting in watercolors.

So join me now, and let's paint some simply beautiful watercolors! We'll begin at the beginning. . . .

Painting Supplies

One of the great advantages of being a watercolorist is the enormous selection of fine quality paints, brushes, papers and other supplies to choose from. Although I have not had the opportunity to try all the different brands available, I am sure they are all good. Every artist, like you, has been or will be introduced to certain supplies that a fellow artist or instructor has recommended. I have always believed that paints, brushes, paper, and other supplies are a personal choice. What may work for one artist may not work for another. So by all means, experiment.

Sometimes, though, your most valuable information will come from another artist, either in person or in book form.

The following is a list of supplies you will need to complete the projects in this book. If what you have is not comparable to what I have listed, visit your local art store so they might help you find an equivalent. Or look through a catalog that offers art supplies through the mail. Some of the items I use—for instance, my brushes—can only be obtained from a particular supplier. For your convenience, I have listed several suppliers' names and addresses in the back of this book.

PAINTS

As you gain experience with watercolor paints, you will discover that the pigments in some brands vary in color and provide different results, even though the name of the color is the same. For example, I have three different tubes of Sap Green. Daniel Smith's Sap Green has a medium staining strength and is a warmer green than Winsor & Newton's Sap Green. Winsor & Newton's Sap Green is a highly staining color and does not lift when you are painting in layers. On the other hand, Holbein's Sap Green does lift, most of the time back to the white of the paper.

The colors I have chosen for these projects have been selected according to their individual performance, some for their uniqueness. It is impossible for me to sample each color from all the different manufacturers to give you a comparable substitute; therefore, I have listed the color I used and its manufacturer in parentheses beside each color. They can be identified by (W&N) for Winsor & Newton Selected List Artist's WaterColours, (D.S.) for Daniel Smith Extra Fine Watercolors, (H) for Holbein Artists' Watercolor, and (S.H.) for Schmincke Horadam. To achieve the best results with the projects in this book, I recommend using the specific tube colors listed at the beginning of each project.

BRUSHES

You will need round brushes in the following sizes: nos. 4, 6, 8, 10 and 12. They should have a nice point and a good spring to them. For flat brushes, you will need a ½-inch (1.3cm) and a 1-inch (2.5cm).

I mainly use the Golden Fleece line of brushes manufactured for Cheap Joe's Art Stuff. The rounds have a nice point for detail and because they are made of synthetic fiber, they have a great spring to them. The flats hold a lot of water and maintain their chisel edge. I paint with a light, bouncing motion, and these synthetic brushes release just the right amount of color that I need each time.

On the first page of each project are the brush sizes I recommend you use for that project. If you wish to work on a larger or smaller scale, you will have to adjust your brush sizes and brushstrokes accordingly.

For softening edges and lifting out color, I recommend using a separate brush *just for water*. You will avoid having to rinse out all that good pigment in your loaded brush each time you need to soften an edge. For softening my edges, I use the no. 5 and no. 7 rounds from the Bette Byrd "Aqua-Sable" 100 series.

For scrubbing out highlights, you will want a brush that's stiff enough to remove the color without causing damage to your watercolor paper. Some artists use oil painters' brushes and trim them. I use the no. 2 and no. 4 Fritch Scrubbers.

PALETTES

You will want a good sturdy palette perferably one that comes with a lid. It should have deep enough wells to accommodate at least a 5ml tube of paint, and offer enough mixing areas for all the puddles of color you will be using. I actually use two types of palette: one type for storing pigment, another for mixing colors. The one I use for my paints is called an extra palette. Each one comes with a lid and fifteen little storage wells that can accommodate more than a 5ml tube of paint. They are manufactured by Cheap Joe's Art Stuff.

I have set up three palettes with the colors I use most often. The first one holds all my yellows and browns; the second one my reds and violets; and the third one, my blues and greens. I also have several other little palettes for colors that aren't used often.

I prefer to squirt my tubes of paints into their designated wells, and then leave the lid off and allow them to dry out. If I'm painting a large area and need to mix a very large puddle of color, I will occasionally opt to squirt out fresh paint to help speed the mixing process. For mixing colors, I use the San Francisco Slant Palette as my mixing tray. The palette has twelve good-sized areas for mixing larger amounts of color and eight small areas for smaller amounts of color.

PAPER

These projects have all been painted on Arches cold-press watercolor paper. You will need several sheets of 300 lb paper cut to the dimensions shown at the beginning of each project. You may also want to cut some smaller sizes to practice painting on before working on your larger piece. In addition, you will need a few sheets of the lighter weight 140-lb. paper cut into smaller sizes (approximately 7½" x 11" or 19.0cm x 27.9cm) to use for testing your colors.

The Arches paper is extremely durable. You don't have to soak or stretch this paper before using it if you don't want to, but I do recommend redistributing the sizing before transferring you drawing (I show you how to do this on page 14). Although I have tried other brands of paper, this remains my favorite. If you wish to use a paper other than Arches, keep in mind that the instructions and the color values given for each project have been based on the use of Arches paper. If you use another type of paper, your results may vary.

MASONITE BOARD, FOAM CORE BOARD, OR A SHEET OF PLEXIGLAS

Any one of these three will provide a sturdy enough surface to attach you watercolor paper to, and to support your hand while painting. Cut your board or Plexiglas one inch(2.54cm) larger on each side than your watercolor paper. For example, a half sheet of watercolor paper measures 22" x 15" (55.9cm x 38.1cm). Cut your board to measure 24" x 17" (60.9cm x 43.2cm). Some Masonite boards can be purchased precut to 24" x 16" (61.0cm x 40.6cm). These will work just fine. There's no need to cut smaller boards to accommodate smaller papers.

Just be sure your board is long enough so you can elevate the top edge about two inches. All the rpojects in this book are painted with the board elevated, because it helps you maintain your watercolor bead.

Miscellaneous Supplies

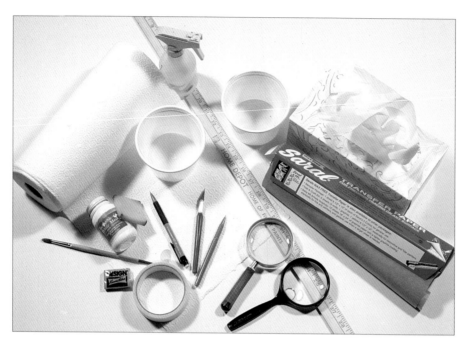

Paper Towels

You'll need these for blotting excess water and color from your brushes. I like to keep my colors clean and fresh while painting, so I am constantly rinsing out and blotting my brush. Use the better-quality towels with a woven pattern. They seem to absorb more water.

Other handy uses for paper towels are to clean contaminated paints, and to cover any areas on your painting you're not working on to protect against unexpected drops of water or paint.

Also, try placing a paper towel under your hand while painting. This will prevent smudging or smearing of your graphite, as well as protect your paper from the oil on your hands. Believe me, there's nothing worse than applying your final wash at the end of a very detailed painting and having an impression of a fingerprint materialize before your very eyes.

Tissues

Make sure your tissues do not contain additives such as lanolin or other oils. I usually paint with a tissue in my left hand, especially when I'm softening edges or lifting out highlights, to quickly blot my brush.

Ultrafine-Tipped Ballpoint Pen

Use one of these to transfer the drawing from the tracing paper to your watercolor paper. Get a color other than black or blue. Colors like hot pink or lime green enable you to clearly see which lines you've already traced.

Drafting Vellum or Tracing Paper

You will need one of these to make your tracing. They come in sheets or rolls, and any brand will do.

Graphite Transfer Paper

I use the wax-free graphite paper made by Saral. It comes in a roll or in sheets. You can use the same piece over and over again before tossing it out. Since it is wax free, it reacts just like pencil lead, and erases just as easily. If you use a different brand, make sure it is wax free. If it has any wax in it, the wax will work as a resist against your watercolor, and you will not be able to remove your lines.

Masking Fluid

For some of the projects in this book, you will need to use masking fluid to preserve the white of your paper in certain areas of your painting. Masking fluid is a liquid rubber-latex product that, once applied to your watercolor paper, will work as a resist to keep the paper underneath white. Once the masking fluid has dried, you can paint right over the top of it with your watercolors without worrying. Use an old brush to apply it, and follow the directions on the bottle. Then use a pickup eraser to remove the masking fluid.

Kneaded Eraser

You'll need one of these for erasing and lightening any graphite lines from your watercolor paper.

Masking or Drafting Tape

Use this to secure your watercolor paper to your board or work surface.

Water Containers

I recommend using at least two containers: one for rinsing out your brush and the other for clean water.

Optional

- Ruler or yardstick (meterstick)
- Craft or utility knife
- Spray bottle of water to moisten your paints.
- Hair dryer to speed drying when testing colors and values.
- A white acrylic paint such as Pelikan Graphic White or gesso can replace a white highlight in an area that was accidentally painted over.
- Magnifying glass
- A reducing lens allows you to see your painting as if you had stepped back from it.

Basic Watercolor Terms

Have you ever heard an artist or teacher use a word or phrase and you were not quite sure what it meant? Every artist uses certain words or phrases to describe what they are doing. Some words are made up, but for the most part, the terminology used in watercolor is pretty much the same. So that you can fully understand the meaning of the painting terms I will be using in the project instructions, here are definitions to some key words and phrases you will come across often. While you are reading and reviewing the instructions for the projects, refer back to this section as often as you need to.

1. Rinse out your brush To remove the color from your brush, thump it lightly on the bottom of your water container. This will open up the brush hairs to the ferrule and clean out most of the color. If you have just finished with a dark color and need to switch to a light color, thump your brush firmly several times on the bottom of your water container. Then transfer your brush into a clean water container and thump it until your brush is clean.

2. Fully load your brush Your brush hairs should be so full of color that when you lift your brush from the puddle, the excess color will drip from the tip. Remove the excess by sliding just the tip of the brush *once* against the rim of your mixing tray.

3. Load your brush Begin as when you fully load your brush, but then remove the excess color by sliding the brush *several times* against the rim of your mixing tray.

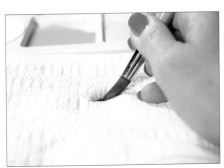

4. Blot or blotting Another way to remove the excess color or water from your brush is by pressing your brush down on a folded paper towel. This term is also used to describe how to remove color or water from your painting (see "Lifting, Scrubbing, Blotting" on page 30).

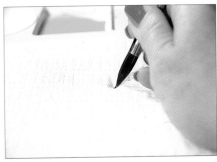

5. Blot lightly Touch the tip of your brush to either a tissue in your hand or against your paper towels just once. This removes just some of the excess color or water from your brush. This term also describes the amount of pressure you apply to the tissue when you are removing color or water from your painting.

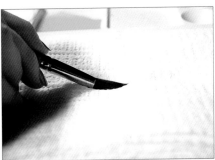

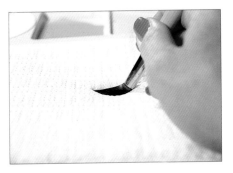

6. Blot well Lay the brush hairs down in one direction on paper towels all the way up to the ferrule. Then lift the brush and lay the brush hairs down in the opposite direction on the paper towels, removing almost all of the color or water.

Basic Watercolor Terms

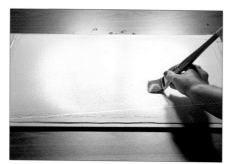

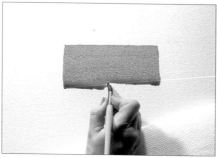

7. Sizing Sizing is a gluelike substance that is applied by the manufacturer either to the surface or throughout the watercolor paper; it helps to slow down the complete absorption of color and water, and prevents any unwanted spreading, allowing you time to paint on the surface and to achieve deep, rich colors with sharp, crisp edges. Since sizing is invisible to the eye, there is no way to tell if too much was applied or if it was evenly distributed across the paper, except after it has been painted on and allowed to dry. White flecks and unevenness, which are difficult to correct, will appear.

I recommend wetting the entire surface first, going back and forth across it with lots of cold water and a clean 2-inch (5.1cm) synthetic brush to redistribute the sizing. Then let the paper dry completely.

9. Controlled wash A controlled wash is the careful and even distribution of color, as in a flat field wash, or color and water as in a graded wash covering a large or small area. The artist is working with a continuous horizontal watercolor bead on a tilted surface.

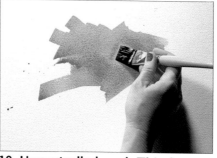

10. Uncontrolled wash This describes the carefree manner in which color or water is applied to paper using a large, flat brush with varying brushstrokes, on either a wet or dry surface.

12. Sheen/Keep moist
"Keep moist" means do not let the area you've just painted dry out. It needs to maintain a sheen. "Sheen" describes the glare that water produces when reflected against light. It tells you the degree of wetness of your paper. The top photo (above) shows the sheen on a freshly painted area; the lower photo (above) shows the same painted area with the sheen almost gone.

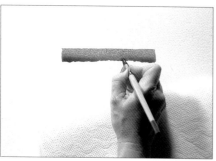

8. Bead The word *bead* in this book refers to the watercolor bead, which is a continuous horizontal formation of droplets of color or water deposited across an area on a sized sheet of watercolor paper while on a *tilted* surface.

11. Charge This word describes how one wet color reacts when another wet color is painted right next to it. Charging is demonstrated on pages 25-27.

How Moist Is Moist?

As you read the instructions for the projects in this book, you'll notice I often say, "Soften the edge with a clean, moist brush." One of the main questions my students ask when learning how to soften an edge is, how much water do you need to have in your brush? In other words, what exactly is *moist*? The dictionary definition of moist is: slightly wet, damp. Since each of us could interpret this differently, I will show you three ways to make your brush moist. I know that all three of these methods work well. Go ahead and test them to see which one you would prefer to use.

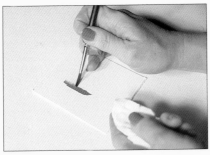

Softening an Edge This is a technique that allows you to soften or blur the hard edge of a previously painted area that is still wet or damp (see pages 28-29). To soften an edge, you use a clean, moist brush.

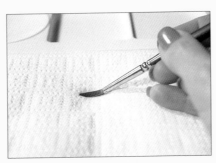

Method 1. Lift your brush out of your clean water container and slide the brush once against the rim to remove the excess. Then lightly stroke the brush back and forth across your folded paper towels. The amount of pressure you put on your brush against the paper towels, and how many times you stroke back and forth, determines how much water will be removed.

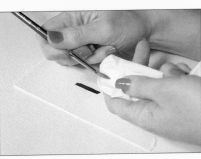

Method 2. After sliding the brush once against the rim of the water container to remove excess water, lay the brush on a tissue in your left hand as shown. How long you leave the brush on the tissue determines the amount of water that will be removed.

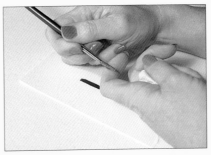

Method 3. After placing a tissue in your left hand, remove the excess water from your brush by sliding it once against the rim of your water container. Lay the brush on the crook of your left pointer finger as shown.

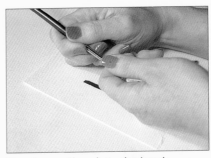

Touch your thumb to the brush.

Slide the brush out from between your thumb and finger, removing the excess water onto your finger. Then use the tissue to absorb the water on your finger. The amount of pressure you apply with your thumb determines the amount of water that will be removed.

How to Mix Colors

Although you can start a painting with pre-chosen colors from your palette, there will be times when you will want a variation of a color. You can do this by mixing it with another color or colors. This allows you to enhance its appearance, gray-down or neutralize the color, warm up or cool down the color's temperature, and sometimes even ruin the color, because not all colors mix well with one another.

So that you may enjoy painting the projects in this book, I have already chosen which combination of colors will allow you to achieve the best possible results.

But before I explain how to mix the correct color, I would like to show those of you who are beginners how to actually make a puddle of color. I will be mixing Permanent Rose + New Gamboge.

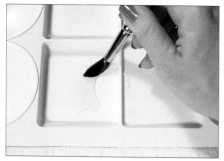

Step 1. Take your brush and touch the bottom of your clean water container. Now with your fully loaded brush, either thump it a couple of times in your mixing well to release the water, or slide the brush against the rim to release the water.

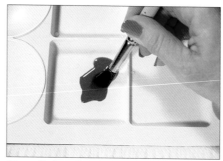

Step 2. Stroke your wet brush across the top of your pigment, Permanent Rose. Bring your brush back to your puddle of water and mix the two together. When you are finished mixing, slide your brush against the rim once.

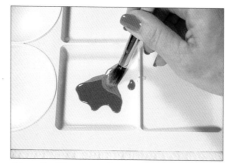

Step 3. Now stroke your brush across the New Gamboge. Bring your brush back to the puddle.

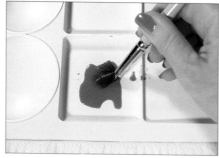

Step 4. Now mix the New Gamboge with the Permanent Rose.

KEEP YOUR COLORS CLEAN

Once your paints have been allowed to dry in their designated wells, there is really no need to rinse your brush between colors. Here's why: Once the pigment has been allowed to dry, only the top layer will get contaminated. The color underneath remains pure. When you are making a puddle of color, just switch back and forth between the two colors you are mixing until you get the correct color, value and size puddle you need. No need to rinse. Otherwise you will be rinsing out good pigment as well as lightening the value of your puddle by adding extra water from your rinsed brush, making it harder to achieve a darker value.

Here's how I clean my colors in two easy steps:

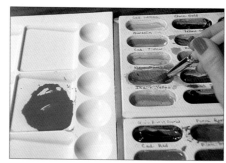

Step 1. After I mix the color I want, I take my clean, wet brush and tickle it across the top of the paint to loosen the contaminated color.

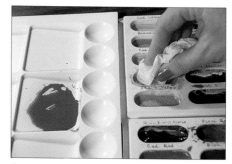

Step 2. Then I take a moist paper towel and lift out the dirty color.

HOW TO MIX THE COLORS FOR THE PROJECTS

At the beginning of each project in this book, I provide you with a listing of all the colors and values you will need to mix (called the "Color Key"), along with color squares showing you what each color should look like after you have mixed it. At right is an example of how the colors will be listed in the Color Key:

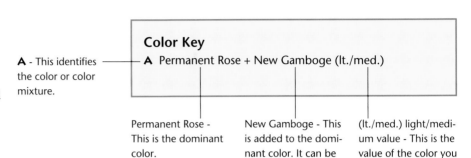

A - This identifies the color or color mixture.

Color Key
A Permanent Rose + New Gamboge (lt./med.)

Permanent Rose - This is the dominant color.

New Gamboge - This is added to the dominant color. It can be half or three-quarters of the amount of the dominant color.

(lt./med.) light/medium value - This is the value of the color you will need for the project. Lt. = light value; med. = medium value, dk. = dark value.

COLOR DOMINANCE

"Color dominance" simply means that you use more of one color in your mixture than you do of the other. The resulting color reveals which color was dominant in your mixture.

Example 1.

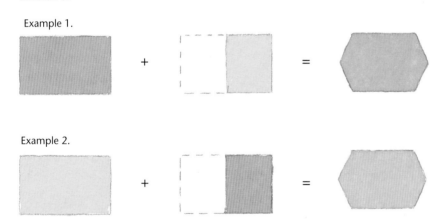

Example 2.

These two colors mixed together will make orange. But in Example 1, since Permanent Rose is the dominant color, the orange will appear cooler, more on the pink side.

In Example 2, if you were to reverse the two colors to be New Gamboge + Permanent Rose, the New Gamboge would now be the dominant color and your orange would appear warmer, more toward the yellow side.

Mixing Three Colors

Example 3.

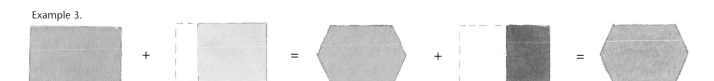

In some mixtures, there will be three colors as shown in Example 3. The Color Key at the beginning of the projects will list them like this:

B Permanent Rose + New Gamboge + French Ultramarine Blue = taupe

The first two colors make up the main color. In this case, it's an orange that is just *slightly* more toward the pink side. The third color (blue) is added to neutralize or gray-down the first two colors. The third color needs to be added sparingly, as little as one-quarter to one-half the amount of the dominant color, until it closely matches the color in the final color square.

Now, because of the limits of color reproduction and printing, the colors shown in this book might differ slightly from those on your test paper. For that reason, I have included an equal sign (=) to help you identify what color you are to achieve. In this case, it should look like the color taupe.

Example 4.

Example 5.

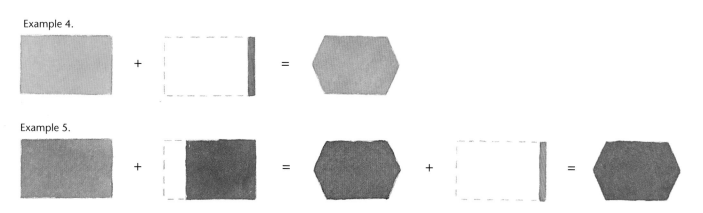

Some of the color combinations have the word *tad* behind the last color listed in the Color Key. To add a tad of color, just lightly touch your brush to the pigment to be added. For instance, in Example 4, Permanent Rose is the dominant color. But I want the Permanent Rose to have a very slight purple tinge to it. So I would add a tad of Carbazole Violet.

The word *tad* will also appear behind the three-color combinations. The third color is added to slightly gray-down the first two colors. For instance, in Example 5, Sap Green is the dominant color, and I have added enough of the French Ultramarine Blue to make a green with a blue cast. The third color, Alizarin Crimson, is a complementary color to the green. So, by adding just a tad, I am slightly graying down the first two colors. Be careful not to let that third color take over!

TEST YOUR COLORS

When mixing your colors, keep in mind that some pigments are easier to lift from your palette with a brush than others. This will affect your mixing process. For instance, if your mixture is Permanent Rose + Alizarin Crimson, Permanent Rose—once dried on your palette—takes some pressure on your brush to get a brushload of color, whereas with Alizarin Crimson you just have to barely stroke your brush across it to load the color onto your brush.

Before you start on the projects, familiarize yourself with your pigments' performance first and test each one, starting with your lightest colors. (Make sure all your paints are clean and dry.)

Step 1. Starting with your lightest color, stroke your clean and wet brush once across the top of your pigment, using the same pressure on your brush that you will be using when testing all the other colors.

Step 2. Then apply that brushstroke of color to a piece of 140-lb. watercolor paper.

Step 3. Write the name of the color next to the brushstroke.

Step 4. Repeat for all your colors, making sure you rinse your brush well between colors. Change your water often to keep your colors clean.

After all your colors have dried on your test sheet, take a look at the colors. In the example below, look how strong Alizarin Crimson is compared to Permanent Rose. Compare Hooker's Green Light to Holbein's Sap Green. Until you become familiar with mixing your colors, you may want to refer to your test sheets. In time, color mixing will become second nature.

The color test sheet below shows that you need to take several brushstrokes of Permanent Rose compared to Alizarin Crimson, of which you will need only one light brushstroke.

Permanent Rose

Alizarin Crimson

Hooker's Green Light

Holbein's Sap Green

Color Mixing Tips

1 Always test your colors on the same brand paper you are painting on to get the same results. To keep costs down, use a lighter-weight paper. For instance, I paint on 300-lb. Arches cold-press paper, but I test my colors on 140-lb. Arches cold-press paper.

When you get the desired value and color, mark it with a circle or arrow. Write in the name or initials of the colors that you used, such as Sap Green + Manganese Blue. (Since I have more than one Sap Green in my palette, I also write the initials of the manufacturer and circle them.) That way, if you have to stop painting for a couple of hours, or even a couple of days, you will be able to mix the colors again and match each color and value to the ones on your test sheet. Always save your test sheets for future reference.

2 Sometimes the value will appear lighter on your test sheet than on your actual painting. What usually has happened is that the area you were painting was intricate and you painted it slowly. As the bead sat on your paper waiting for you to move it with your brush, the color had

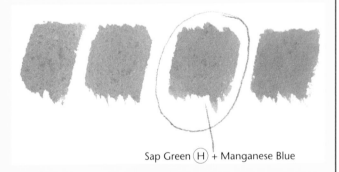

Sap Green (H) + Manganese Blue

more time to be absorbed by the paper, resulting in a darker value. If the area you are about to paint looks intricate, try testing your color in a similar manner to that of your actual painting.

3 Always try to mix your paints to achieve the color and value first. Then make a mental note of roughly how many times you stroked your brush across each color: for instance, three brushstrokes of Sap Green, two brushstrokes of Winsor Blue and a tad of Alizarin Crimson. When you get the right color and value, repeat that combination plus water until you get the size puddle you need. With practice, this, too, will become second nature.

How to Check Values

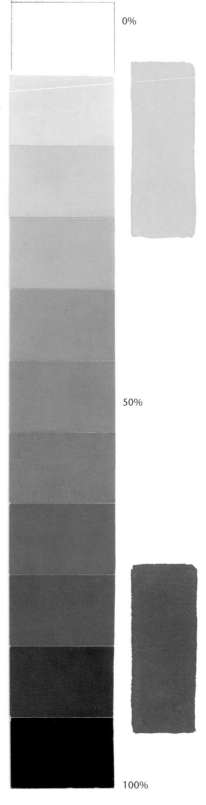

Now that you have learned how to mix colors and have a better understanding of how your pigments can perform, I will explain how to gauge their individual values. Value is, quite simply, the relative lightness or darkness of a color and is an important element of a good painting. In fact, value is so important that, even if your colors are perfect and your drawing accurate, if your values are off, the painting may never look right.

Artists generally learn how to check values by using a gray scale like the one shown here. The lightest value is pure white, the darkest, pure black. A color's value can be estimated by placing it next to the gray scale and finding which shade or shades of gray most closely match the lightness or darkness of your color.

At the beginning of each project, I list not only each color you need, but each color's value. To keep things simple, we'll be using a five-step scale of values:
1. Light (lt.)
2. Light/medium (lt./med.)
3. Medium (med.)
4. Medium/dark (med./dk.)
5. Dark (dk.)

The overall value of a color can be gauged against a gray scale. The scale shown here has been divided into 10 percent increments, from 0 percent (pure white) to 100 percent (pure black).

I have placed yellow and purple alongside the gray scale. Compare these two colors to the grays. When you look at the yellow, your eye will be drawn to the lighter values (lower percentages) of the gray scale. When you look at the purple, your eye is drawn to the darker values (higher percentages). Matching colors takes practice, so don't be concerned if it seems difficult at this point.

0%

50%

100%

MAKING A FIVE-STEP VALUE SCALE

Here's an example of how to make a five-step value scale using a light-value color—yellow—and a dark-value color—purple. First, trace two rows of five squares each on a small piece of scrap watercolor paper. Then choose a tube of yellow paint and a tube of purple. The yellow shown here is New Gamboge and the purple is Permanent Violet.

Step 1. Starting at the right-hand side of each row, make a small puddle of each color. The puddles should be thick in consistency, containing the least amount of water, but not looking like pure pigment. You want to have the colors at their darkest value. In the project instructions, I have labeled this as a color's dark (dk.) value.

Step 2. Now move over to the left-hand side of each row. Take a small brush-load of the dark color and make a new puddle, adding enough water to make a light (lt.) value.

Step 3. Next, move to the middle squares in each row. Make another new puddle by adding a brush-load of the light value of each color and a brush-load of the dark value to make an approximate medium (med.) value.

You have now established three value ranges for these two colors: a light, a medium and a dark. But quite a few of the colors that you will be mixing for the projects fall somewhere between the light and medium values and the medium and dark values. So let's break the values down further.

Step 4. In a new puddle, mix a brush-load of the light value of each color with a brush-load of the medium value and make an approximate light/medium (lt./med.) value.

Step 5. In the final puddle, mix a brush-load of the medium value of each color with a brush-load of the dark value and make an approximate medium/dark (med./dk.) value.

You now have established the five most commonly used values for both colors. So, you will be able to make the appropriate value of any color that the projects call for. When you are gauging the colors' values, make them approximate. A little too dark or a little too light will not make that much difference.

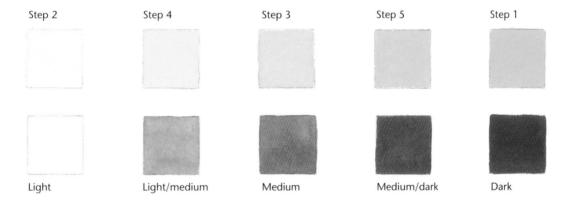

Step 2 Step 4 Step 3 Step 5 Step 1

Light Light/medium Medium Medium/dark Dark

Painting a Controlled Wash

Whether you are new to water-color, or familiar with it and would like to lighten your touch or learn how to paint a more even, controlled wash, this exercise will help you develop your skills and gain confidence. Once you learn how to establish, and experience painting with, the watercolor bead, you will gain a better understanding of your painting progress. You will know whether you need to speed up or slow down your brushstrokes, use less color and water, or add more. But, most of all, you will gain a greater amount of control.

ESTABLISHING AND PAINTING WITH THE WATERCOLOR BEAD

Tape a 15" h × 11" w (38.1cm h × 27.9cm w) piece of 300-lb. water-color paper to your board. With your pencil, draw several boxes 4" h × 2" w (10.2cm h × 5.1cm w). Elevate the top of your board. For this exercise you will be using Permanent Rose which is a transparent, nonstaining color. Mix a large puddle, approximately two table-spoons' worth. You do not want to run out of color in the middle of painting your wash. Add water until the Permanent Rose, has about a medium value. Rinse a no. 10 or no. 12 brush in clean water and blot well.

Step 1. To start the bead, fully load your brush with color. Position the brush in your hand as shown in the photo. Start at the top left-hand corner of your box. With the tip of your brush and a light touch, paint down the left side approximately ½" (1.3cm). When you lift up your brush from the paper, a narrow bead of color will be released from your brush. If you did not get a bead, you may have placed too much pressure on your brush. Try again, lightening your brushstroke.

Touch your brush to the narrow bead of color you have just painted. Lift your brush. You have now re-leased more color from your brush. Repeat until you get a good-sized bead. The sizing in the paper and the correct tilt of your board will prevent it from running down your paper.

Step 2. Again, with a very light touch, paint ½" (1.3cm) line across the top of the box. Lift your brush and let the color release.

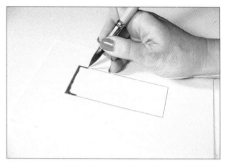

Step 3. Touch your brush back down into the bead from where you lifted your brush, and paint across another ½" (1.3cm). Lift your brush and let the color release.

Continue this pattern to the right side of the box. Paint down the right side about ½" (1.3cm). Lift your brush and let the color release.

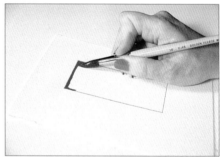

Step 4. Now fully load your brush with color again, and tilt the handle of your brush so it rests on the area of your hand shown here. Instead of painting with just the tip of your brush, you will now be painting with about one-third of your brush hairs. Now touch your brush back into the area where you left off, and paint ½" (1.3cm) to the left, touching the tip of the brush against the bottom edge of the narrow bead that you have already painted across the top of the box.

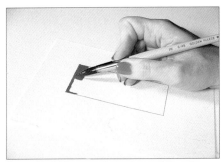

Step 5. Lift your brush and let the color release. Continue painting to the left, repeating the ½" (1.3cm) pattern until you are about halfway across. Lift your brush and let the color release. Then immediately fully load your brush again.

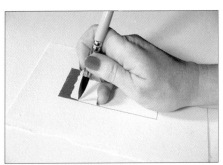

Step 6. Continue repeating the ½" (1.3cm) pattern until you reach the left side. You have now established what is called the watercolor bead.

Next, tilt your brush handle upwards again, and paint down the left side approximately ½" (1.3cm). Lift your brush and let the color release.

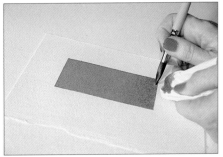

Step 7. Now that you have established a fairly good-sized bead, you will be able to paint to the other side of your box by having to fully load your brush only once each time across. The bead basically paints the wash for you. The light touch of your brush directs it.

As you near the end of your box, do not load your brush anymore. Use the color that's left in the bead. Angle your brush handle upwards. Paint across a ½" (1.3cm) on the bottom line, touching your brush to the bead. Repeat all the way across. Your box is now completely painted.

Blot your brush firmly on your paper towels. Do not rinse your brush. Place a tissue in your left hand. With your blotted brush, lightly touch the lower left corner of the box. Your brush will reabsorb some of the bead. This is called mopping up. Blot your brush on your tissue, then continue to lightly mop up more of the bead. When a good portion of the bead is mopped up, you may then lightly go across the bottom edge with the tip of your brush for a short distance to mop up more. Blot and repeat until you get to the other side. Let your wash dry completely.

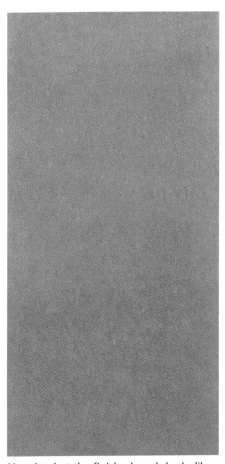

Here is what the finished wash looks like. Because of the amount of control you have with the watercolor bead, the color and value are even and consistent, not streaky or blotchy.

Painting a Controlled Wash

COMMON WASH PROBLEMS

Here are a few common problems that may occur when you are learning how to paint a controlled wash, and some solutions on how to avoid them.

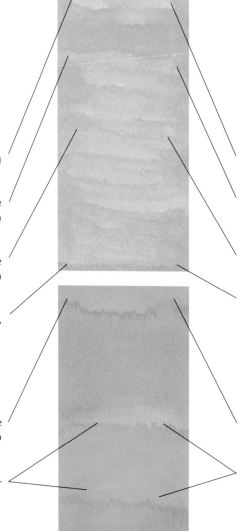

Problems

1. The bead was never established, causing the top to dry out.

2. Too much pressure was applied to the brush, causing a lighter value and uneven application.

3. Too much distance was covered in a single brushstroke throughout this sample, which made the wash dry too quickly.

4. Color was not mopped up when finished, causing a ballooning effect.

Solutions

1. Make sure to establish a bead before painting.

2. Don't push down so hard with your brush while you are painting. Use lighter brush-strokes.

3. Shorten the distance and release the color from your brush more often.

4. Remember to mop up any excess color when you are finished.

1. The bead was not large enough, and more color was added after the top had started to dry out, causing a ballooning effect.

2. The bead was used until it ran out, then re-established, causing another ballooning effect.

1. Make sure the bead is fully established and the area above remains moist.

2. Load your brush often to maintain a consistent size to the bead.

1. Wash was going well until the end but the brush was rinsed out and not properly blotted before mopping up excess bead.

1. There is no need to rinse out your brush at the end. Just blot your brush well each time you mop up.

How to Charge Colors

Now that you are familiar with painting a wash, I'll show you how to charge two colors together. Charging is a technique that allows colors to mix directly on the surface of your watercolor paper, as opposed to pre-mixing them in your palette, or mixing tray. Charging creates a smooth transition between two colors, a gradual color change without hard edges. Charging can be used to create the illusion of shadows and of three-dimensional form.

Let's start with two transparent, nonstaining colors, New Gamboge and Permanent Rose. Make puddles large enough so that you do not run out of color. Elevate the top of your board. Draw several 4" h × 2" w (10.1cm h × 5.1cm w) rectangles on your Arches 300-lb. cold-press watercolor paper.

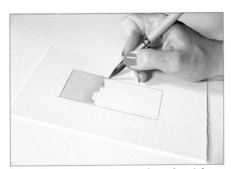

Step 1. Fully load your brush with New Gamboge. Establish your bead and paint the top third of your rectangle. Make the bottom of your bead an irregular line, not straight across. Rinse your brush and blot well.

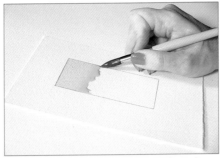

Step 2. Now fully load your brush with Permanent Rose. Tilt your brush back in your hand and, starting on the right side, lightly touch the bead with the angled tip of your brush.

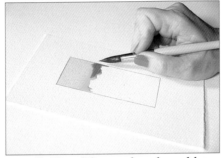

Step 3. Now lift your brush and let the color release. There is no need to touch the paper with your brush.

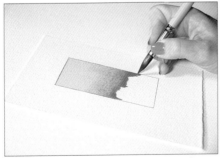

Step 4. Continue to lightly touch the bead and release more color, using a light, bouncing motion with your brush as you work you way across to the other side of the bead. Your new bead will now be orange and will be larger that the first one. Paint with the orange bead until the bead gets smaller.

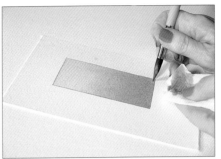

Step 5. Rinse your brush and blot well. Fully load your brush with Permanent Rose, and charge into the orange bead, using the same bouncing motion across the bead with your brush. Finish painting the rectangle with Permanent Rose. Mop up the excess color from your bead in the same manner as you would when painting a wash.

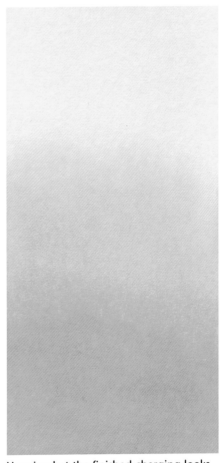

Here is what the finished charging looks like. See the smooth transition between the yellow and orange, and the orange and the pink?

Charging Effects

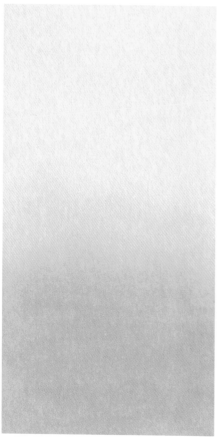

Charging can even be done in an area as small as a flower petal. To charge in a very small area, follow the steps below.

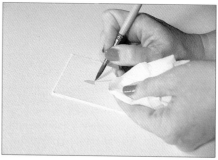

Step 1. Load your brush with New Gamboge, then blot your brush lightly on a tissue held in your other hand. Paint as far as you would like your first color to go, touching your brush lightly to the paper with each stroke. You do not need a bead. Quickly rinse your brush and blot very well.

To get a cleaner transition between colors and less of an orange color, after you charge the Permanent Rose into the New Gamboge, paint with the orange color only a short distance, then mop up some of the pink-orange color with your brush.

Rinse your brush, blot well, then fully load your brush with Permanent Rose. Finish painting the rectangle with the Permanent Rose, and mop up any excess color with your brush.

With time and practice, you will be able to reverse the colors about midway and to create some exciting effects like these with charging. You'll also be able to cover larger areas much quicker, and actually touch the brush to the paper with a sweeping motion. Practice does pay off in the long run!

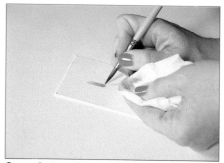

Step 2. Load your brush with Permanent Rose, and blot your brush lightly on the tissue. With light, overlapping brushstrokes, charge the colors together. Do not paint with the orange color. Quickly rinse your brush and blot well. Load your brush with Permanent Rose again, and blot lightly on your tissue. Charge into the orange color with light, overlapping brushstrokes, then finish painting the shape with the Permanent Rose.

COMMON CHARGING PROBLEMS

Watch for some of these problems as you practice charging your colors together. The solutions are easy. Just keep trying!

Problems

1. The value of the New Gamboge was too light and did not create an orange color when Permanent Rose was charged in.

2. After the brush was rinsed, it was not blotted enough before being loaded with Permanent Rose, so the resulting value was much lighter.

3. Too much pressure was applied to the brush when mopping up, causing the area to dry out.

Solutions

1. To achieve an orange color, the New Gamboge and the Permanent Rose should be close in value.

2. Make sure that you blot your brush well before reloading it with color.

3. Just gently stroke the brush across, using less pressure.

1. Not enough bead to charge into, so the color dried.

2. The bead was used until it ran out, causing a ballooning effect.

3. Ran out of color and used what was left in the brush to finish.

1. Keep area above wet, and leave a bead to charge the second color into.

2. Make sure to maintain a bead.

3. Make a larger puddle so you don't have to stop to mix more color.

1. Problem—The yellow dried before the pink could properly charge.

1. Solution—Keep the yellow moist before charging.

3. Problem—Yellow color dominated over the pink.

3. Solution—Mop up the yellow bead before charging.

2. Problem—The pink color charged all the way up to where the yellow started.

2. Solution—Remember to blot your brush once lightly before charging.

How to Soften Edges

There are going to be times while you are painting your washes and charging your colors that you will want an edge or several edges not to appear hard, but soft, as when rendering the gentle folds of fabric and lace, or a duckling's downy feathers. Softening an edge is a technique that is used to make a hard edge soft or blurred while your wash is still damp or wet. How soft you want the edge to appear determines the amount of water you will need in your brush. For a tighter, more controlled look, you would *soften the edge with a clean, moist brush* (how to make your brush moist is explained on page 15). For a much softer look, you would *soften with water* using a clean brush that had a little more water in it than the moist brush.

A softened edge is another way to transition a color's value, at the same time shaping and forming your subject matter.

This technique also allows you the freedom to place a touch of color in an area that has been previously painted and soften just those edges, all without having to prewet or paint the entire area first.

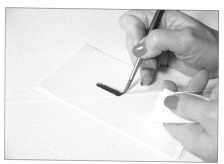

Example 1. First, using clean water, rinse the brush you have just painted with, blot your brush until it's moist, and then in one full swoop of the brush, soften along the color's wet or damp edge. The color will charge into the newly wetted area. Rinse out the brush again, blot, and soften the new, lighter-value edge. Repeat until the color stops charging into the softened area. This depends on how far you want the color to charge and on how soft you want your edge to be.

Example 2. Another way to soften an edge is similar to Example 1, except instead of using one full swoop, you soften the edge using short, continuous brushstrokes. This will give a very soft look to your edge.

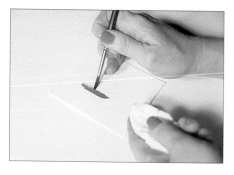

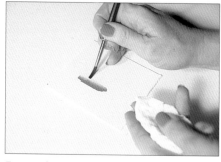

Example 3. Here's the method I use for softening my outside edges: After painting a short distance, I go back to the top and gently push the flattened tip of my moist brush slightly into the edge, then slightly pull some of the color out, push back in again, then pull slightly out. The motion is similar to a narrow zigzag stitch on a sewing machine. I do this at a medium-to-fast speed.

When I reach the bottom I do not lift my brush from the paper. Instead, I reverse the direction and go back up the softened edge, continuing to soften with the same narrow zigzag motion.

When I reach the top, I rinse my brush, blot, and repeat the same softening technique on the new, lighter-colored edge. This method allows the edge to be consistently softened, while still maintaining its original shape. It also causes less of the lighter value of the color to show along the softened edge. Although it can be a little rough on your brush, the results are worth it.

SOFTENING EFFECTS

You can also soften an inside edge and vary the color's value using light, overlapping brushstrokes with clean water. The value of the original color you just painted becomes lighter as you pull the color down.

Step 1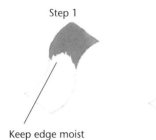

Step 2

Step 3

Keep edge moist Keep edge moist

Step 1. Paint the shape as far as you would like the original value of your color to go.

Step 2. While your edge is still wet, pull some of the color down with your clean brush that has a little more water in it than a moist brush, using light, overlapping brushstrokes for a short distance. You have now created a lighter value of the original color.

Step 3. Quickly rinse your brush and blot. Repeat with light, overlapping brushstrokes until you achieve an even lighter value of the color or the white of the paper.

You can also apply color in the center of an area and then soften the surrounding edges. This technique (shown at right) gives the illusion that the shape is rounded or is curling over.

First, soften along the top edge, working quickly so that your bottom edge doesn't dry out. Then soften along the bottom edge.

COMMON EDGE PROBLEMS

As with any other painting technique, you may run into some problems when learning how to soften edges. Here's how to fix them.

> **TIP**
>
> If you are using a staining color or painting in a dry or warm atmosphere, I suggest stopping to soften an edge after every inch or inch-and-a-half (2.5cm to 3.8cm) of painting.

1. Problem - Too much water in the brush caused the water to charge into the edge.

1. Solution - Blot a little more water from your brush before softening.

2. Problem - Paint dried too quickly, causing a hard edge.

2. Solution - Speed up the painting process or stop after a short distance and soften a section of the edge.

3. Problem - Color charged over too far.

3. Solution - The wash was too wet. Mop up some of the color before softening the edge.

Lifting, Scrubbing, Blotting

Sometimes when you are painting, you'll need to remove color from your paper. Perhaps your color or value is too dark, or you've made a mistake, or you've painted over an area you didn't mean to. Or, on the positive side, you want to create some interesting effects.

Here I'll show you three easy ways to lift out color with a moist brush, scrub out color with a stiff brush, or blot up color with a tissue.

HOW TO SCRUB OUT COLOR

This is a good way to remove color from an area that has already dried. You'll need a stiff-bristled brush and a dry tissue.

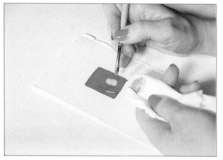

Step 1. Wet your stiff brush and tap it once lightly on the side of your water container. Lightly scrub the area, using either overlapping brushstrokes or a back-and-forth motion on your paper.

Step 2. With your tissue, blot up the excess color from the scrubbed-out area. Remove the color from your brush by thumping it on the bottom of your water container. If you need to remove more color, repeat these steps.

For removing color on a heavily pigmented area, it is best to blot with a paper towel, not a tissue. A tissue will leave lint particles, which are difficult to remove, on the pigment surrounding the scrubbed-out area.

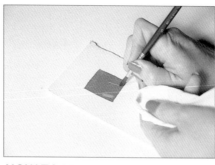
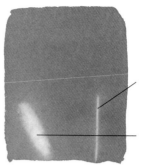

Lift out using the chisel edge of the brush

Lift out using the flat side of the brush

HOW TO LIFT OUT COLOR

Use this technique to lift color from an area that is wet, damp or dry. You'll need a clean, moist brush and a dampened tissue.

Step 1. With your clean, moist brush, make several brushstrokes in the area where you want to lift out the color. Wipe the color from your brush onto your dampened tissue. Repeat the brushstrokes. If you need to remove more color, rinse out your brush, blot it on the tissue, then lift out more color. Wipe the color on your tissue. Repeat as needed.

Step 2. If you want to lift out narrow lines, shape your brush into a chisel edge. Using short brushstrokes, lift out a line of color, then blot your brush on your dampened tissue.

Tissue Blotting

Wet wash

Damp wash

Dried color | Using very light pressure | Using light pressure | Using firm pressure

HOW TO BLOT WITH A TISSUE

Tissue blotting is an easy way to lighten the value of an area you have just painted; it can add texture to your painting. How much color is lifted depends on how wet or damp your wash is or the amount of pressure applied to your tissue.

In the examples above, the top row of squares shows the results when you tissue-blot on a wet wash. The bottom row shows the results when you tissue-blot on a damp wash.

Step 1. To blot, take a dry tissue and crumple it in your hand. This breaks up the stiffness of the tissue. If you are blotting to create texture, crumple it more.

Step 2. Press the tissue to the wet area to blot up the amount of color you want lifted. Firm pressure on a wet wash can lighten a color's value considerably.

Transferring Your Drawing

A drawing can go through many transformations before it's ready to be used in a painting. Although drawing directly onto the watercolor paper is the ideal way to go, sometimes it is better to make all the changes and adjustments on vellum or tracing paper first and then transfer your final drawing onto your watercolor paper using graphite.

To transfer your drawing you will need to gather the following supplies: drafting vellum or tracing paper, technical pencil, masking or drafting tape, wax-free graphite, a brightly colored, ultra-fine-tipped ballpoint pen, a kneaded eraser, and a ruler.

Here is a step-by-step guide to transferring the drawings from the pages in this book onto your watercolor paper.

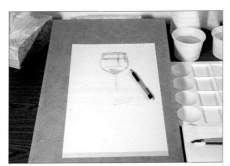

Step 1. Trace your drawing. Lay a piece of drafting vellum or tracing paper over the drawing shown at the beginning of each project. Using your pencil, trace along all the lines as accurately as you can. Each line serves a purpose. When you are finished, remove your paper and check to see that you have copied all the lines. Now enlarge or reduce your tracing to the size you wish, using the grid system or a photocopier.

Step 2. Attach your watercolor paper to your board. Place your watercolor paper right side up on your board. Hold the paper up to a light and look for the brand's watermark. If it reads backwards, you are looking at the back of the paper. Attach your paper to your board by securing all four sides with masking or drafting tape. Now prep your paper (see Sizing page 14.)

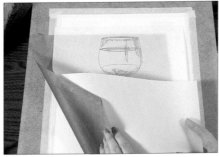

Step 3. Attach your drawing and insert your graphite. Center your tracing over your paper and tape it at the upper left and the upper right. The tape will serve as hinges. Lift your tracing and lay your graphite paper face-down on top of your watercolor paper.

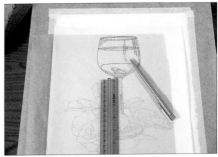

Step 4. Transfer your drawing onto your watercolor paper. Trace a few lines, then lift your tracing and graphite to check your pressure. If your graphite lines are too dark, they will be difficult to remove. If they're too light, you will have to draw them all on again. When you have finished, check to see that you have transferred all the lines.

Also check for accuracy. A good drawing is very important: Straight lines must be straight. Erase any mistakes with your kneaded eraser, then trace over the lines again. Or remove your drawing and the graphite, and draw them directly onto the watercolor paper with your pencil. Remove any unwanted smudge marks with your kneaded eraser.

Now you are ready to paint any of the projects in this book. Enjoy!

Stained Glass Iris

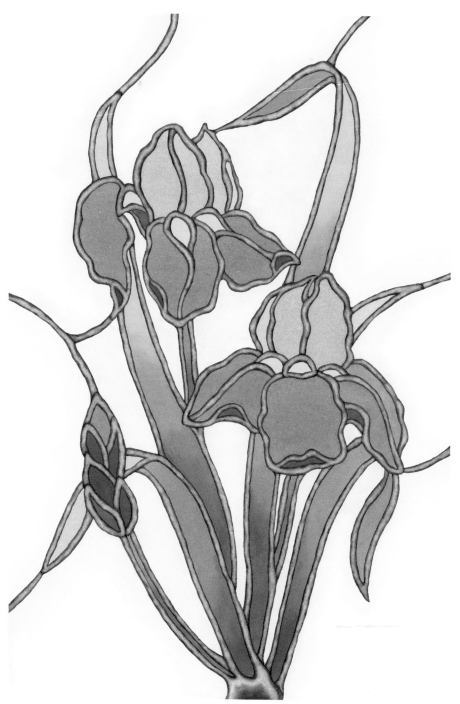

Palette
Cobalt Blue (D.S.)
Carbazole Violet (D.S.)
French Ultramarine Blue (W&N)
Hansa Yellow (D.S.)
Permanent Sap Green (W&N)
Winsor Blue (W&N)
Cadmium Yellow (W&N)
Neutral Tint (W&N)

Brushes
no. 8 round, to paint the lead
no. 10 or no. 12 round, to paint the
 petals, leaves and background

Other
A half-sheet (22" h x 15" w)
(55.9cm h x 38.1cm w) Arches
300-lb. cold-press watercolor
paper

Color Key
A Cobalt Blue +Carbazole Violet
 (tad) (lt./med.)
B Cobalt Blue + Carbazole Violet
 (tad) (med.)
C French Ultramarine Blue +
 Carbazole Violet (med./dk.)
D Cadmium Yellow + Hansa Yellow
 (med.)
E Hansa Yellow + Permanent Sap
 Green (med./dk.)
F Permanent Sap Green (med./dk.)
G Permanent Sap Green + Winsor
 Blue (dk.)
H Cadmium Yellow (lt./med.)
I Neutral Tint (med./dk.)

Now that you have practiced and learned the watercolor techniques of painting a controlled wash, charging colors, and lifting out color from a damp wash, you are ready to paint your first project. The pattern for this project is an adaptation from actual stained glass windows designed by Judy Miller. I created this project especially for beginners. The flower shapes are large and easy to block in with color using the controlled wash technique. The leaves are long and narrow to make the charging of colors easier and more manageable. If you happen to go slightly outside the lines while painting the flowers and leaves, the lead design helps to conceal any imperfections.

Before you begin, look through the next few pages to see how I've designed the project to be easy to follow. Each step shows you exactly what areas you'll be painting, and a picture in the upper-right corner shows you how your painting will look when you finish that step. Just follow the instructions like a recipe, and you can't go wrong!

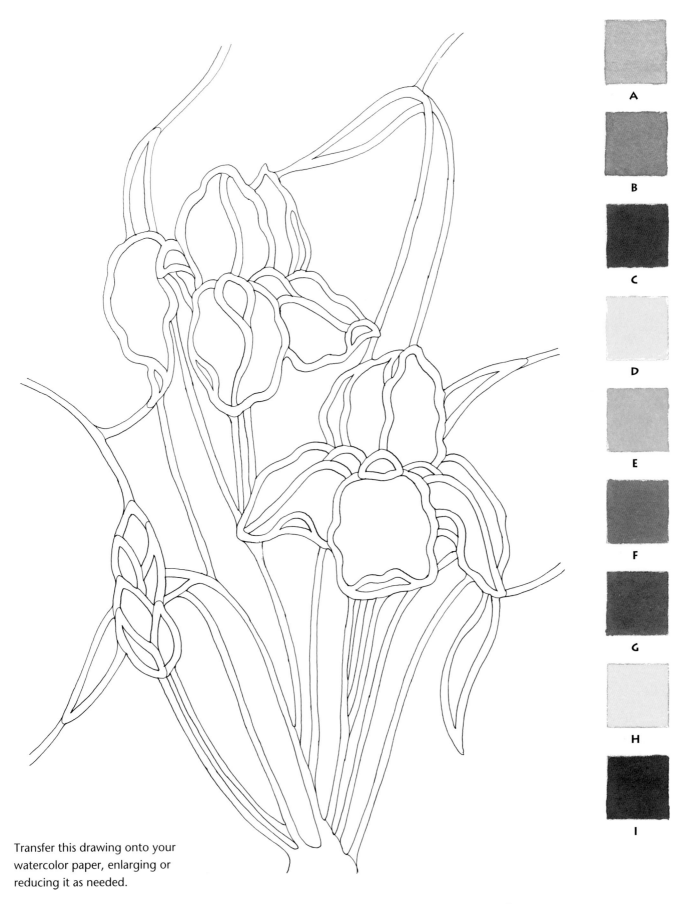

Transfer this drawing onto your
watercolor paper, enlarging or
reducing it as needed.

A

B

C

D

E

F

G

H

I

STEP 1 Paint the flowers and the leaves

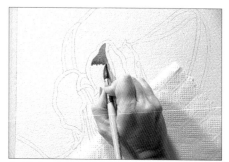

1. Paint the top petals of the irises.
Mix color **A**. Paint the iris at the top first. Fully load your clean brush with **A** and paint a section of the petal using the controlled wash technique as shown in the photograph. Let that dry.

Fully load your brush again and paint the next section of the petal in the same manner. Continue until all the top petals on both irises have been painted. Rinse your brush in clean water and blot well.

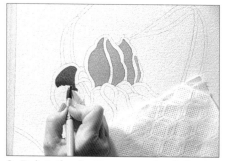

2. Paint the bottom petals. Mix color **B**. Paint the iris at the top first. Fully load your clean brush with **B**, and paint a section of the petal, using the controlled wash technique as shown in the photograph. Let that dry.

Continue painting until all the bottom petals on both irises have been painted. With **B** still in your brush, paint the small section of the iris bud on the lower left side. Let that dry. Rinse your brush in clean water and blot well.

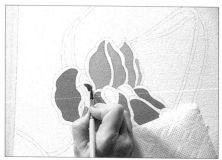

3. Paint the dark shadows. Mix color **C**. Paint all the dark shadow shapes on the lower petals, starting with the iris at the top. Load your clean brush with **C**, and paint the small shape as shown in the photograph. Let dry.

Continue painting until all the dark shadow shapes on both irises have been painted. With **C** still in your brush paint the two small sections of the iris bud on the lower left. Rinse your brush in clean water and blot well.

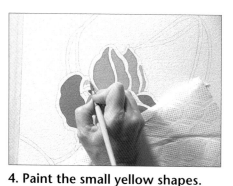

4. Paint the small yellow shapes.
Mix color **D**. Load your clean brush with **D** and, starting with the iris at the top, paint the small yellow shape as shown in the photograph. Let dry.

Continue painting until all the yellow shapes on both irises have been painted. Let dry. Rinse your brush in clean water and blot well.

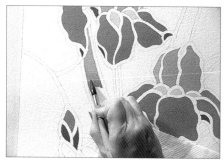

5. Paint the leaves. Mix colors **E**, **F** and **G**. Paint the tall leaf on the left side of the top iris first. Fully load your clean brush with **E**, and paint the top section of the leaf. Let dry.

Fully load your brush with **E** again and, starting below the iris petal, continue to paint with **E** as far as the sample shows you to. Rinse your brush and blot well.

Fully load your brush with **F** and, using the charging technique, charge **F** into **E**. Paint with this color combination as far as shown. Rinse your brush and blot well.

Fully load your brush with **G** and charge **G** into **F**. Finish painting the leaf with **G**.

Continue painting the leaves using the color squares and the sample at right to help guide you on which colors to use. Let each leaf dry before painting the next one.

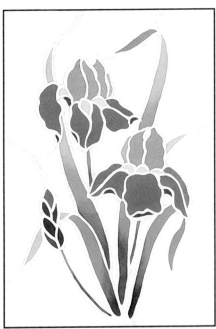

When you are finished with Step One, your painting will look like this.

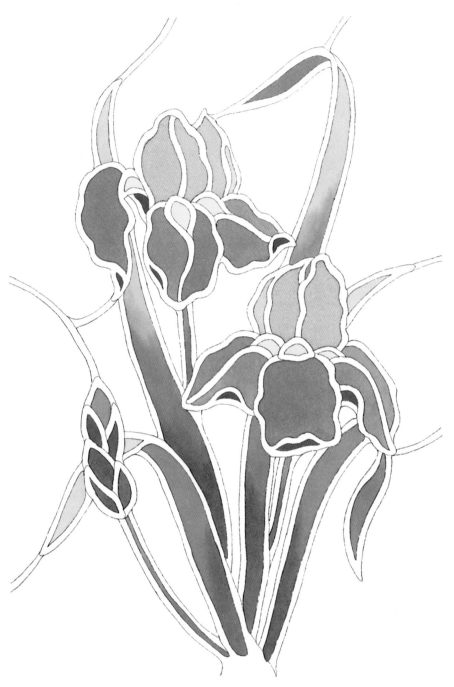

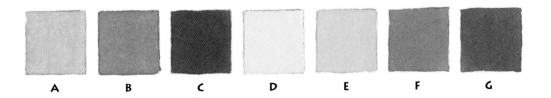

A B C D E F G

STEP 2 Paint the background and the lead

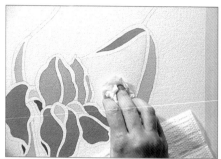

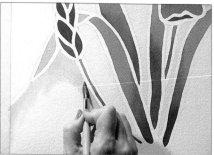

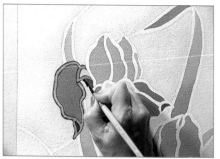

1. Paint the inside areas of the background. Mix color **H**. Fully load your clean brush with **H** and paint one of the solid yellow areas as shown in the photograph. When the sheen is almost gone, lightly blot the area with a tissue to create texture. Let dry. Continue painting in the same manner until all the inside areas have been painted.

2. Paint outside areas of the background. Mix color **H**. Paint all the outside areas next, starting with the lower left side. Fully load your brush with clean water, and really wet the entire area, stopping about ½" (1.3cm) from the lead line. While the water still has lots of sheen, fully load your brush with **H**, and paint along the lead line and outwards toward the water, allowing **H** to charge into the water.

Continue to paint along the lead line with **H** until that entire section has been painted. When the sheen is almost gone, lightly blot with a tissue. Let dry. Continue to paint in the same manner until all the outside areas have been painted.

3. Paint the lead. Mix color **I**. Paint all the sections of lead around the irises first, and then the leaves, following the directions given in the example below. Let each section dry completely.

Use very short, bouncing brushstrokes as you move your brush down the center of the lead. Make sure the strokes overlap one another as shown in the example. This motion will release enough water to push the color to the sides. While you are painting the lead, rotate your board so that you are always painting toward yourself.

I recommend practicing painting the lead on a scrap piece of 300-lb. paper first, until you feel comfortable with the results you are getting.

How to Paint the Lead

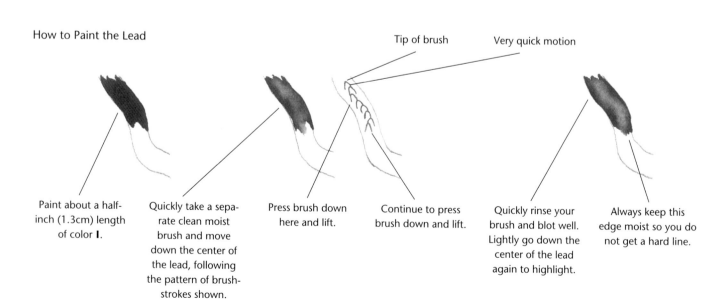

Tip of brush

Very quick motion

Paint about a half-inch (1.3cm) length of color **I**.

Quickly take a separate clean moist brush and move down the center of the lead, following the pattern of brushstrokes shown.

Press brush down here and lift.

Continue to press brush down and lift.

Quickly rinse your brush and blot well. Lightly go down the center of the lead again to highlight.

Always keep this edge moist so you do not get a hard line.

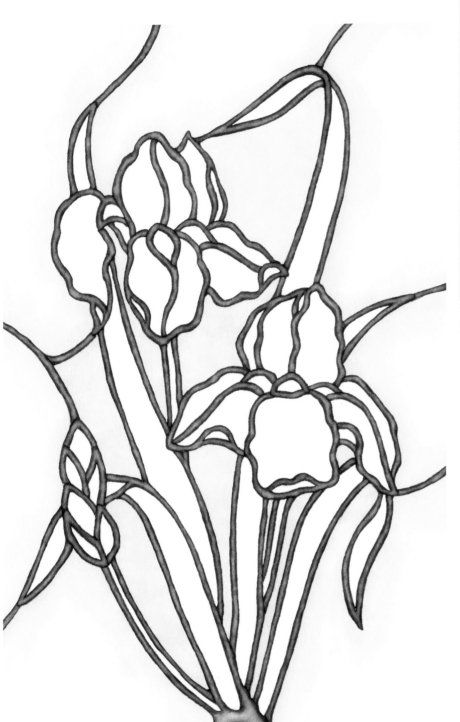

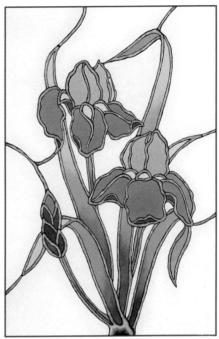

When you are finished with Step Two, your painting will look like this.

H I

Problems? Here are some easy ways to fix them!

Critique Your Work

Now that you have completed all the steps, compare your painting and its values to the finished painting on the facing page. Take a look at your:

• Flowers. If the value of your petals is too light, paint over them again, but use a lighter value of the color. If your value is too dark, go over the entire section again, using clean water instead of paint. Apply pressure to the brush to move the pigment around on the paper as you go over the shape. When you are finished, lay a tissue over the petal shape and evenly blot up the excess color. Let dry. Then paint over the petal shape again with a lighter value.

If some of your petals appear blotchy or uneven, wet the area in the same manner as if you were painting with color. When you reach the area you would like to fix, gently tickle the area with your brush, moving around the color until you are pleased with the results, then finish painting the area with the water. Follow the same steps given for correcting the petals that got too dark. Let dry.

• Leaves. Follow the same guidelines given for the flowers. If one of the values on the charged leaves is too light, you can go back in and just darken the value that needs to be darkened without disturbing the value of the other color. For example, if your value for the dark-green color was too light, go back in as if you were painting the entire leaf again, except use clean water. Start at the top with the clean water. Gently move your brush just as you would if you were painting, being careful not to lift or disturb the color underneath. When you reach the area that needs to be darkened, blot your brush, fully load it with a lighter value of the color, then charge the lighter color into the water. Finish painting the entire leaf. Let dry. This also works in reverse, starting with color and then switching over to clean water.

• Background. If your yellow appears too bright, or the values too dark, you can tone it down or lighten them by tickling over the areas with a clean, moist brush and then blotting with a tissue. If that does not work, then use your scrubby brush and clean water.

• Lead. If all your color pushed to the edge, take a clean, moist brush and gently tickle along the darker color, and blot with a tissue. Let dry. Then repaint that section.

If your lead got too dark and you do not have a highlight traveling down the center, just take your scrubby brush and, with clean water, lightly scrub down the center of the lead, then blot with a tissue.

Stained Glass Iris
Dawn McLeod Heim
Watercolor on Arches
300-lb., cold-press
paper 22" x 15"
(55.9cm x 38.1cm)

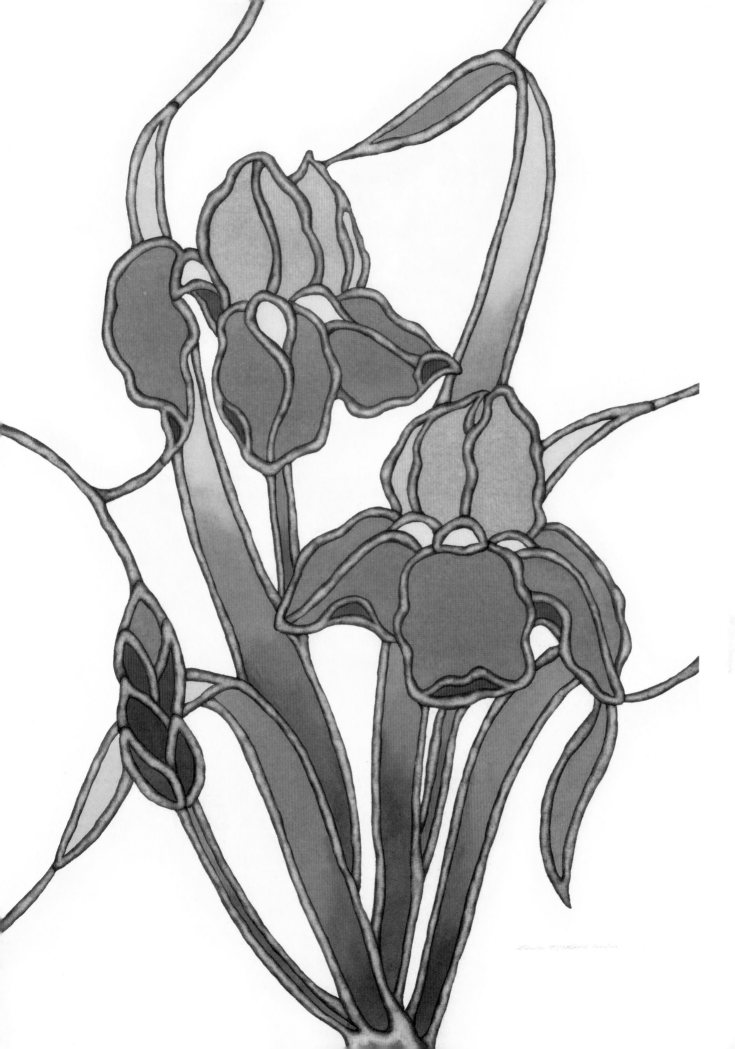

Truffle and Notecard

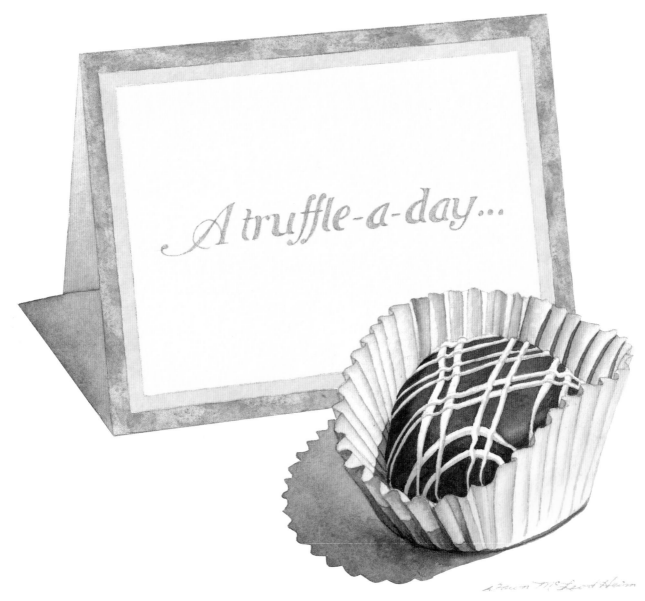

A truffle-a-day...

In this project, you will learn how to paint a milk chocolate truffle, as well as how to imitate the look of icing using the white of the paper. You will also learn how to create the illusion of a pleated gold-foil wrapper, and how to use the three primary colors—as well as colors from your subject matter—to make your reflecting and cast shadows appear to take on a glow.

Palette	**Brushes**
Raw Sienna (W&N)	no. 6 round, with a nice point
Permanent Rose (W&N)	no. 8 round
New Gamboge (W&N)	no. 10 or 12 round
French Ultramarine Blue (W&N)	
Permanent Brown (D.S.)	**Other**
Burnt Umber (W&N)	An eighth sheet (7½" h x 11" w)
Viridian (D.S.)	(19.0cm h x 27.9cm w) Arches
Manganese Blue (H)	300-lb., cold-press watercolor paper

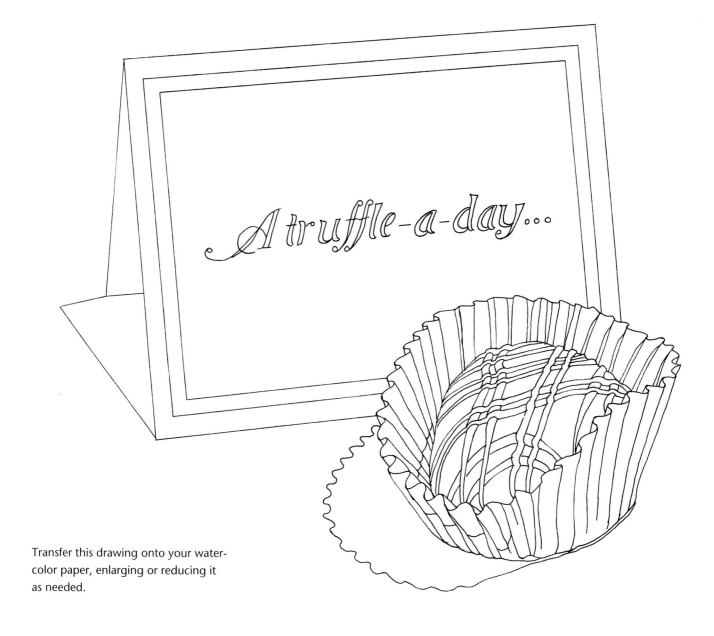

Transfer this drawing onto your water-color paper, enlarging or reducing it as needed.

Color Key

A Raw Sienna (med.)

B Permanent Rose + New Gamboge + French Ultramarine Blue = taupe (lt./med.)

C Permanent Rose + New Gamboge + French Ultramarine Blue = taupe (med.)

D Permanent Brown + Burnt Umber (dk.)

E Viridian (med.)

F Manganese Blue (med.)

A B C D E F

STEP 1 Establish shadows and underlying colors

1. Paint the gold wrapper. Mix colors **A** and **B**. Paint the outside of the wrapper first. Load your brush with **A** and, starting on the left side, paint to the left as far as shown. Quickly dip your brush into clean water, and slide the excess color off the brush. Finish painting with the lighter value, leaving a white highlight at the bottom. Soften the edge with water, as shown. Let dry. Rinse your brush and blot well.

Load your brush with **B**, and paint down one of the inside pleat lines. Soften over to the next pleat line with water. Let dry. Repeat on all pleats, letting each area dry before painting the one next to it, and leaving some areas white, as shown.

2. Paint the shadows on the icing. Mix color **B**. Load a brush with a nice point with **B**, and paint the shadows along the lines as shown. Let dry. Paint the shadow across the lower left side of the truffle next, softening upwards with clean water. Let dry.

3. Paint the front of the card. Mix color **A**. Take a small brush-load of **A**, and add enough water to make a very light value. Fully load your brush with the lighter value, and paint the front of the card with an even wash. Let dry.

4. Paint the shadows. Mix colors **A**, **B** and **C**. Paint the inside shadow of the notecard first. Load your brush with **B**. Then dip the tip of the brush into **A**. Starting at the top, paint downwards with a light, bouncing motion, releasing the grayed yellow. Stop about midway and load your brush with **B**. Finish painting the shadow with **B**. Let dry. Rinse your brush and blot well.

Fully load your brush with **C**, and paint the card's cast shadow, working your way from the left side to the right. Stop about three-fourths of the way across. Blot your brush. Quickly load your brush with **A**, and gently charge **A** into **C**. Finish painting the cast shadow, including along the lower front edge of the card. Let dry.

Paint the cast shadow from the truffle next. Load your brush with **C**, and dip the tip of the brush into **A**. Starting at the back, paint toward yourself as far as shown. Blot your brush. Load your brush with **C**, and paint as far as shown. Blot your brush. Dip the tip of your brush into **A**, and finish painting the shadow. Let dry.

When you are finished with Step One, your painting will look like this.

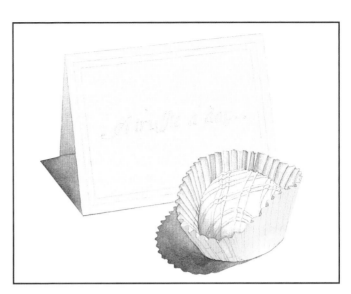

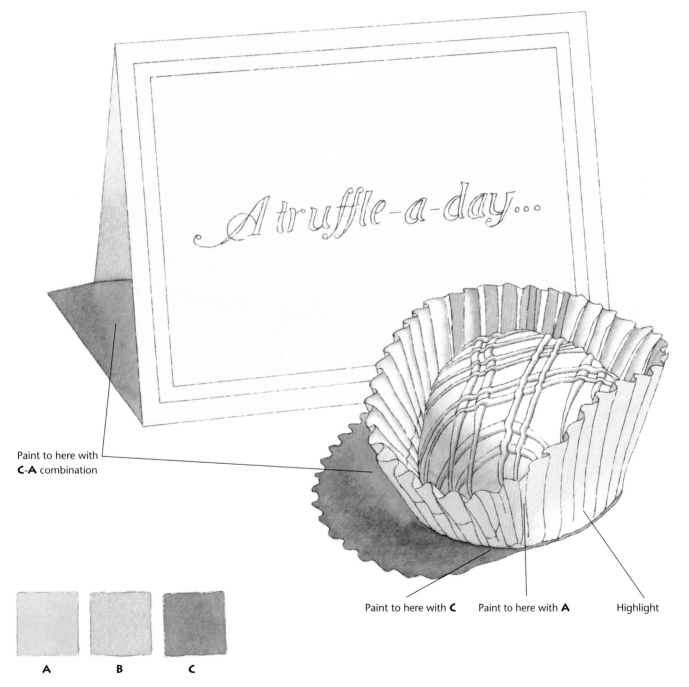

A truffle-a-day...

Paint to here with **C-A** combination

Paint to here with **C** Paint to here with **A** Highlight

A B C

Add finishing touches to truffle and notecard

1. Paint the gold wrapper. Mix colors **A** and **C**. Load your brush with **A**, and paint down the left side of one of the pleat lines. Quickly soften the left edge with clean water. Let dry. Repeat the same for the other pleats, letting each one dry before painting the one next to it.

Load your brush with **C**, and paint the shadow areas along the front and left side, softening some of the edges with water as shown. Let dry. Paint the small cast shadow under the wrapper, lightly softening along the edge with water. With **C** still in your brush, paint the shadows on the inside pleats, softening the one edge with water.

2. Paint the truffle. Mix color **D**. Load your brush that has a nice point with **D** and, starting at the back, paint all the brown areas, blotting each one lightly with a tissue. Do not blot the areas in front. When you are finished, lift out the two highlights with a clean, moist brush as shown.

3. Paint the notecard. Mix colors **A**, **E** and **F**. Load your brush with **A**, and paint a short distance, blot lightly with a tissue, continue painting for another short distance, and blot again. Continue painting in the same manner until all the yellow areas are finished. Let dry. Rinse your brush and blot well.

Load your brush with **E**, and paint a short distance. Blot lightly with a tissue. Take a separate brush and load it with **F**. Charge **F** into **E** and paint another short distance. Blot lightly with a tissue. Continue to use alternating brushstrokes of **E** and **F** in this manner. Let dry. With the brush that's loaded with **F**, paint the wording, blotting each letter lightly with a tissue. Let dry.

TIP

If you happen to accidentally go over one of the white areas on the icing, don't panic and do not scrub out. Take an old brush that still has a nice point and using either gesso, a graphic white, or an acrylic white, paint over the area.

When you are
finished with Step
Two, your painting
will look like this.

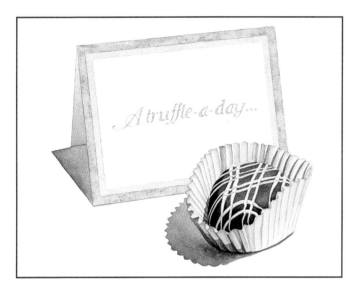

Paint a short distance
with **E** . . .

. . . then charge in
with **F**. Repeat all
along border.

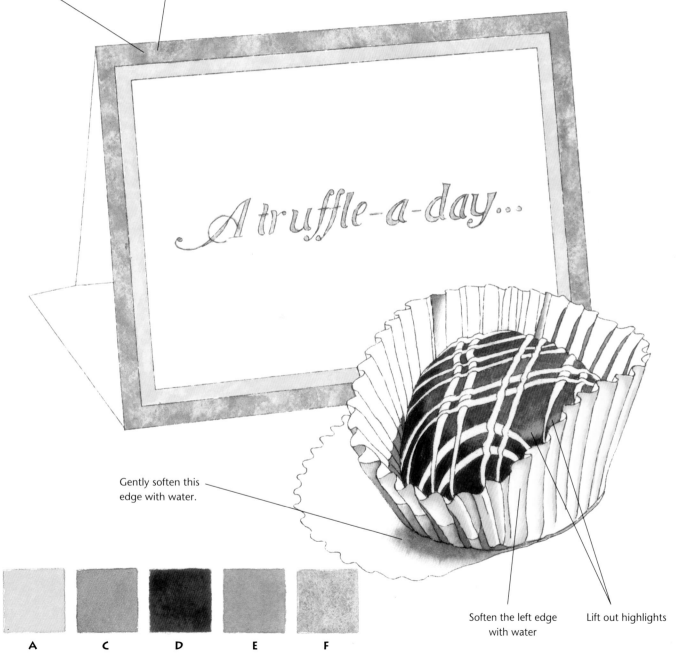

A truffle-a-day...

Gently soften this
edge with water.

Soften the left edge
with water

Lift out highlights

A C D E F

Problems? Here are some easy ways to fix them!

Critique Your Work

Now that you have completed all the steps, compare your painting and its values to the finished painting on the facing page. Take a look at your:

• Gold wrapper. If you don't see enough value change in the yellow pleated area, either darken the value on the left, or lightly scrub out some of the color with your scrubby brush on the right side, then blot with a tissue. Do the same for the areas on the inside pleats.

• Chocolate truffle. If the light brown areas got too dark, take a clean moist brush and lightly tickle the color, being careful not to go over the white icing, then blot with a tissue. If your darker areas are still too light, paint over them again.

• Notecard. If your colors got too dark, take your scrubby brush and lightly scrub over the darker areas, blotting with a tissue. If the colors are too light, paint over them again, but use lighter values.

• Cast shadows. If your cast shadow is too light, paint over it again with lighter values. If it happened to get blotchy, load your brush with a light value of the color and, using very light brushstrokes, paint over the shadow again until you reach the blotchy area, then lightly tickle the blotchy spot, smoothing and evening out the color. Then finish painting the shadow.

If your shadow got too dark, take a brush loaded with water and paint over the entire shadow, placing some pressure on your brushstrokes to lift the color. Then tissue blot. Your shadow should be a light brown.

If you still have hard outside lines, with a clean, moist brush, tickle along the lines, and blot. Let the shadow area dry completely. Mix your shadow color again, but make it a lighter value, and add a little more French Ultramarine Blue than before. Paint your shadow again. Let dry.

Truffle and Notecard
Dawn McLeod Heim
Watercolor on Arches
300-lb., cold-press
paper 7½" x 11"
(19.0cm x 27.9cm)

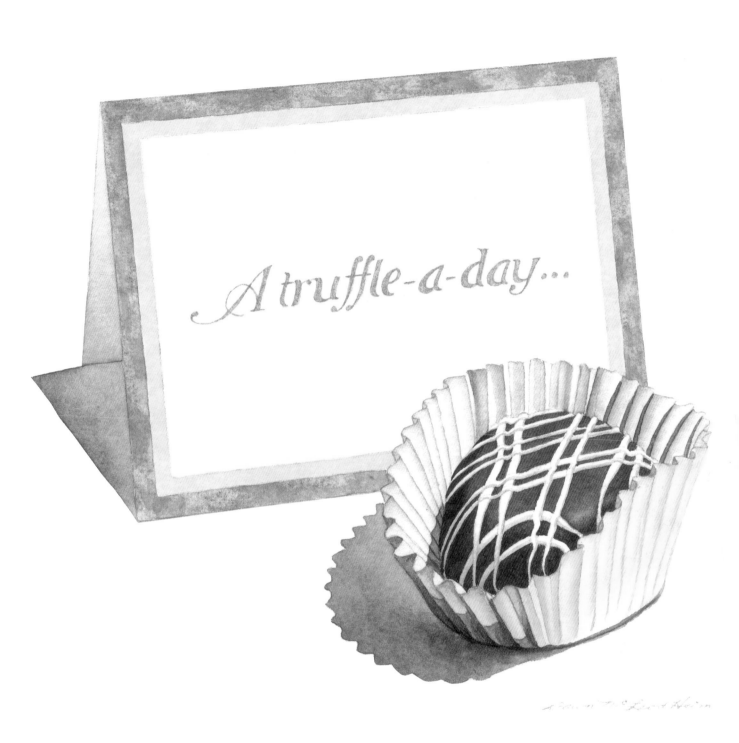

A truffle-a-day...

Cluster of Berries

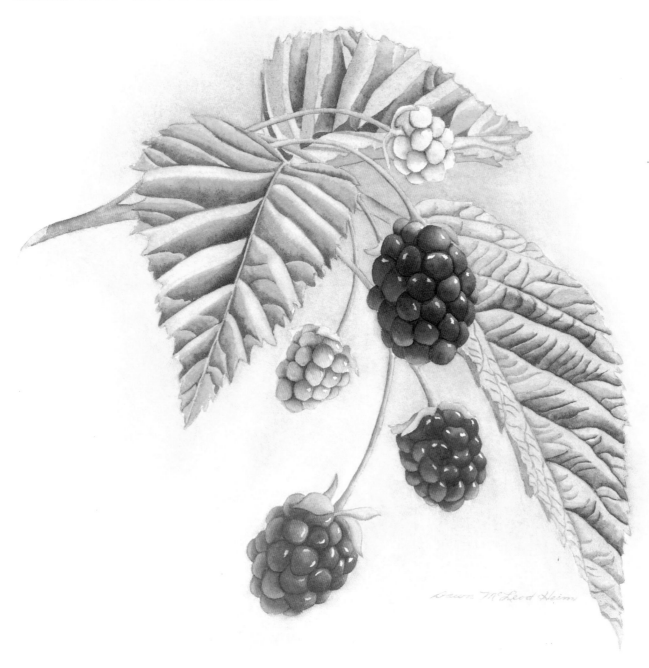

I n this lesson, you will learn how to paint berries to make them appear three dimensional, as well as which colors you can use to make them appear lush and ripe. You will also learn how you can add more texture to your leaves by using a sedimentary color such as Manganese Blue.

Palette
Winsor Red (W&N)
Sap Green (H)
Alizarin Crimson (W&N)
Winsor Blue (W&N)
Manganese Blue (H)
Cobalt Blue (D.S.)

Brushes
no. 6 round, with a nice point
no. 8 round
no. 10 or no. 12 round

Other
A quarter-sheet (15" h x 11" w)
 (38.1cm h x 27.9cm w) Arches
 300-lb. cold-press watercolor paper

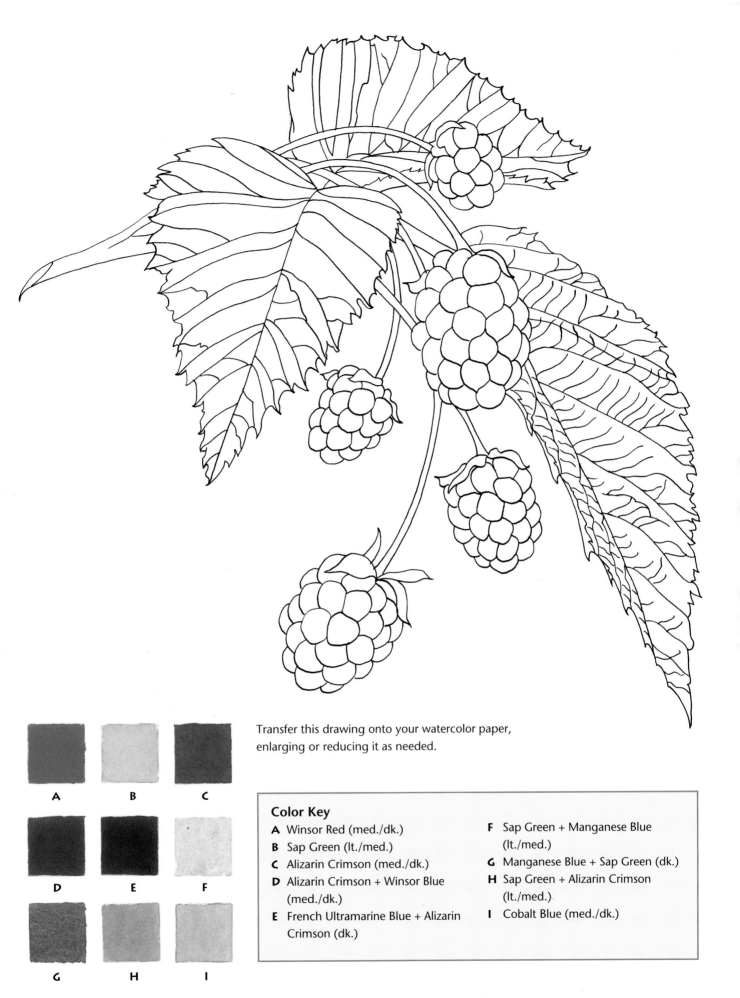

Transfer this drawing onto your watercolor paper, enlarging or reducing it as needed.

Color Key

A Winsor Red (med./dk.)

B Sap Green (lt./med.)

C Alizarin Crimson (med./dk.)

D Alizarin Crimson + Winsor Blue (med./dk.)

E French Ultramarine Blue + Alizarin Crimson (dk.)

F Sap Green + Manganese Blue (lt./med.)

G Manganese Blue + Sap Green (dk.)

H Sap Green + Alizarin Crimson (lt./med.)

I Cobalt Blue (med./dk.)

Underpainting color on berries and leaves

1. Remove excess graphite from berries. With your kneaded eraser, remove enough graphite from the berries to make the lines barely visible.

2. Paint the berries. Mix colors **A**, **B**, **C**, **D** and **E**. You will need two brushes: one for pigment, another for clean water. Start with the small berry at the top. Load your pigment brush with **A** and paint a short distance. Rinse your brush and blot well. Load your brush with **B** and charge **B** into **A**. Finish painting the segment with **B**. Paint all the segments on the right in the same manner. Rinse your brush and blot well.

Load your brush with **B**, and paint all the segments on the left side following the directions in the sample. Let dry. Paint all the segments on the left side twice. Paint the other **A**/**B** combination berry in the same manner.

Continue to paint the other three berries with the same technique shown in the sample, using the colors indicated. Remember to let each segment dry completely before painting the one next to it.

3. Paint the leaves. Mix colors **B** and **F**. With your kneaded eraser, lift off most of the graphite from the highlight line that separates the darker area from the lighter area. Paint the leaf on the left first. Load your brush with **B** and, starting at the center vein, paint the area between the side veins. Let dry.

Continue to paint the rest of the areas on the leaf in the same manner, letting each section dry before painting the next one.

With **B** still in your brush, paint the underside of the top leaf and the curled-over sections of the leaf on the right. Rinse your brush and blot well.

Load your brush with **F**, and paint those sections on the other two leaves. Let dry.

4. Paint the stems. Mix colors **B**, **C** and **F**. Load your brush with **C** and, starting with the main stem on the far left, paint along the top as shown. Rinse your brush and blot well. Load your brush with **F**, and charge **F** into **C**. Finish painting the stem with **F**. Repeat the same for the section of stem between the two leaves. Rinse your brush and blot well.

Load your brush with **B**, and paint all the narrow fruit-bearing stems, as well as the tiny leaves on top of each berry. Be sure to let each one dry before painting the one next to it.

TIP

Always stir puddles containing Manganese Blue before loading your brush. Otherwise, your brush will pick up all the sediment that settled at the bottom of your puddle.

Berry Segment

Step 1. Apply a brushstroke of color, and keep moist.

Step 2. Soften the edge, and keep new edge moist.

Step 3. Rinse out your brush and blot well. Finish softening the edge. Let dry.

Some segments have a white highlight.

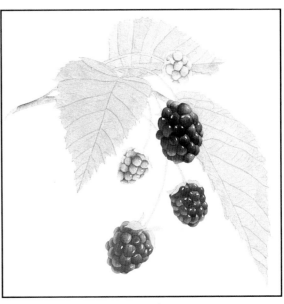

When you are finished with Step One, your painting will look like this.

Highlight line

Paint each section between the side vein lines separately

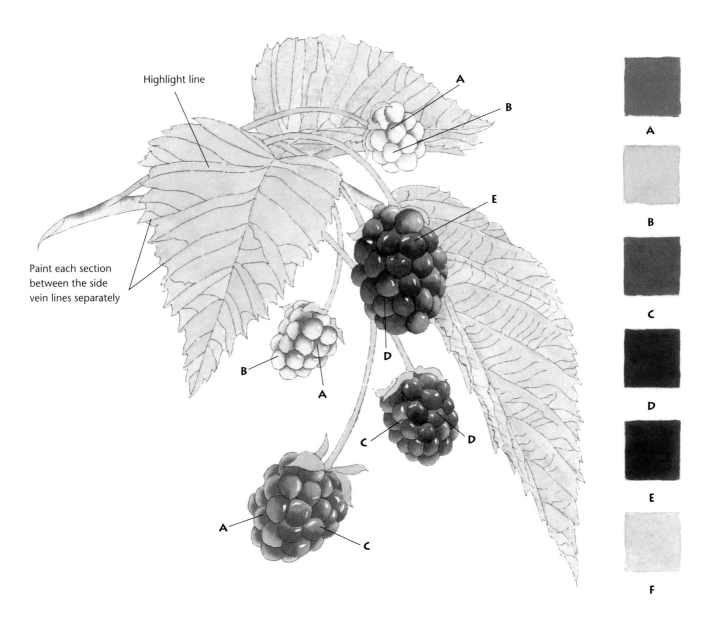

A

B

C

D

E

F

STEP 2 Paint the background and the shadows in the berries and leaves

1. Paint the berries. Mix colors **A**, **D**, **E** and **H**. Load your brush with **H**, and starting with the berry at the top paint between the segments on the left side, softening the edges as shown. With **H** still in your brush paint the segments on the left side of the other berry in the same manner. Let each segment dry completely before painting the one next to it. Continue to paint the areas between the segments, using the colors shown in the sample, and softening the edges on the left. Let dry.

2. Paint the leaves. Mix colors **B**, **F**, **G** and **H**. Paint the leaf on the left first, starting at the top. Load your brush with **B**, and paint along the long side vein and up to the highlight line, softening along the edge as shown. While the wash is still moist, load your brush with **G**, and paint along the same vein again, allowing **G** to charge upwards into **B**. *Do not paint upwards with* **G**. Continue until all the sections on that leaf are painted.

Paint the leaf on the right next. Load your brush with **F** and, on the far right, paint along some of the long side veins again, softening with water as shown.

Load your brush with **G** and paint only those small, dark vein lines, softening each vein line with water as shown.

Load a nicely pointed brush with **B**, and paint only those small vein lines on the left side of the leaf. Do not soften the edges. Also with **B**, paint the small vein lines on the right side of the leaf, softening each vein with water as shown. Rinse your brush and blot well.

Load your brush with **H**, and paint only those side vein lines on the left side of the same leaf. Do not soften the edges. With **H**, also paint the small veins on the right side of the leaf, softening those edges with water. Let each small vein dry completely before painting the vein next to it.

Paint the sections on the top leaf with **B**, **F** and **G**, softening some of the edges with water, as shown. Let dry.

3. Paint the stem. Mix colors **B**, **C** and **H**. Load your brush with **C**, and paint along the top part of the stem. Quickly rinse your brush and blot well. Load your brush with **B**, and charge **B** into **C**. Finish painting the rest of the stem with **B**.

Load your brush with **H**, and paint a narrow strip of color along the underside of each of the long, fruit-bearing stems, gently softening to the right with a clean moist brush. With **H** still in your brush paint the small leaves on the top of the berries, softening with water as shown. Let dry.

4. Paint the background. Mix color **I**. Paint the background clockwise, rotating your painting so that you are always painting towards you. Turn your painting upside down and start on the right side by the end of the stem.

Fully load your brush with **I**, and paint as far as the darkest value of the blue shown for that area. Dip your brush into your water container, and slide your brush once against the rim. With light overlapping brushstrokes, paint towards you with the light value. Rinse your brush and slide it once against the rim and finish softening towards you with the clean water.

Continue to alternate between color **I** and the water until the background is completely painted. When you get to the narrow areas by the berries, switch to a smaller brush. Keep an eye on your edge so it doesn't dry out.

TIP

To make painting the background easier, divide it into sections, and let each section dry completely. Use clear water when overlapping into the previously painted area. You will get a smoother transition and avoid getting hard edges.

A B C

D E F

G H I

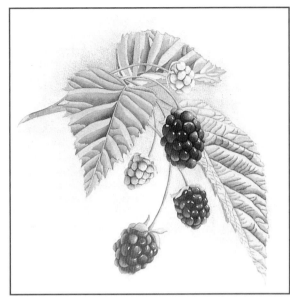

When you are finished with Step Two, your painting will look like this.

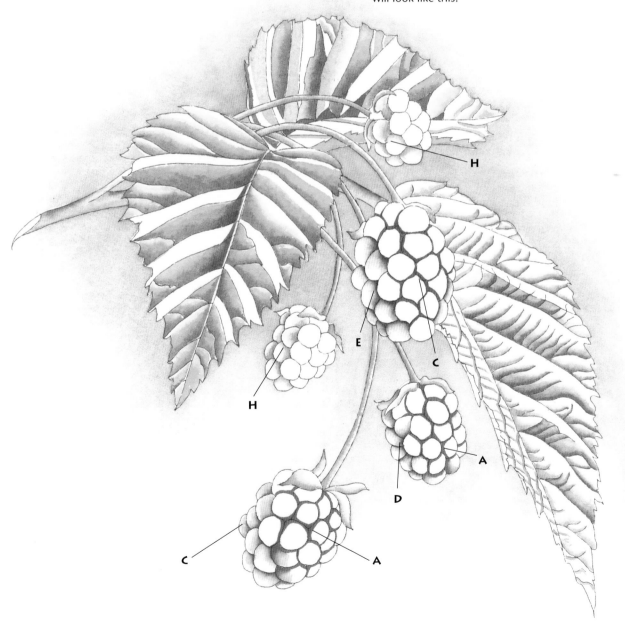

Finishing
touches

Take a clean, moist brush and light-ly go over some of the highlights on the segments on the left side of the berries to help tone them down. With a scrubby brush, lightly lift out some of the color along and above the highlight lines on the left leaf.

Critique Your Work

Now that you have completed all the steps, compare your painting and its values to the finished painting on the facing page. Take a look at your:

• Berries. If the segments on the right side of the berries are too light, paint over them again with a lighter value of the color. If they are too dark, first try to lift some of the color, using a clean, moist brush. If that doesn't work, then use your scrubby brush and lightly lift some of the color out.

If you lost some of your highlight on the right side of the berries, put one in using a tiny bit of acrylic white paint.

• Leaves. Are the values close to that of the finished project? If not, go back in and deepen the areas, using a lighter value of that color. If the light areas in your leaves look too dark, gently lift out some of the color with your scrubby brush, then blot. If there is still not enough contrast between the light and dark values on the leaves, paint over all the dark values again.

• Background. If the value of your blue is too dark, take a clean, wet brush and re-wet over the blue area, then with your tissue blot up some of the color. If the blue areas are too light, paint over just the blue area again, then with a clean, wet brush gently charge clean water around the painted area, softening outwards until the water is clean. Let dry.

If your blue took over your whole background, take your scrubby brush and lightly scrub out the blue, then blot. Continue working towards the berries and leaves until the amount of white you want is visible.

Cluster of Berries
Dawn McLeod Heim
Watercolor on Arches
300-lb., cold-press
paper, 11" x 9"
(27.9cm x 22.9cm)

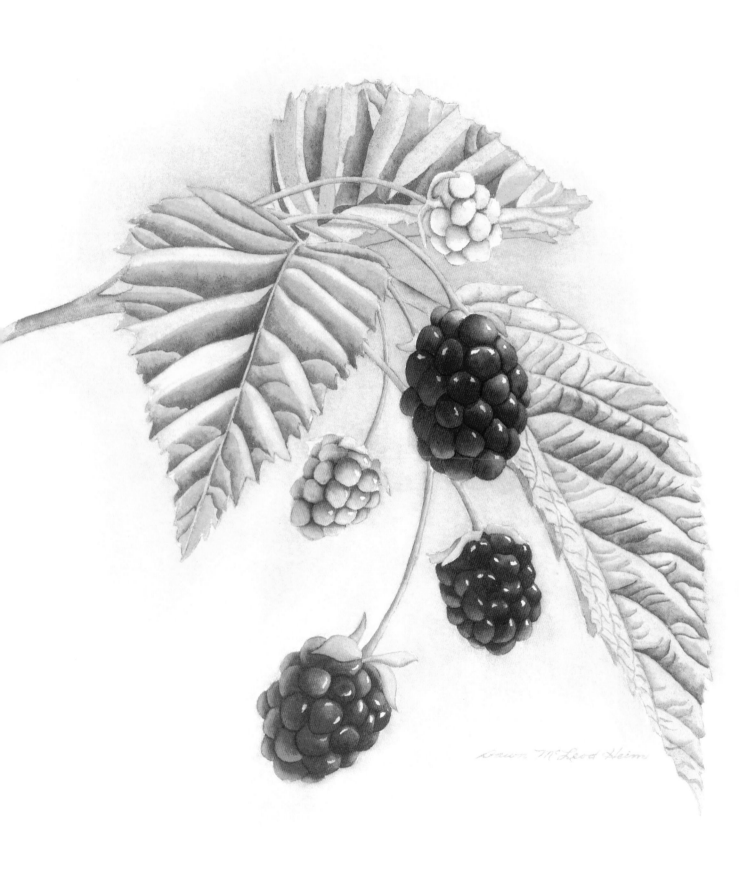

Wine Glass and Rose

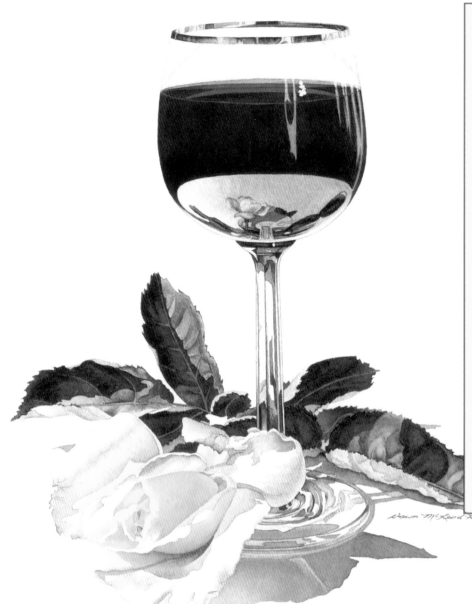

Color Key

- **A** New Gamboge (lt./med.)
- **B** Permanent Rose (lt./med.)
- **C** Sap Green (lt./med.)
- **D** Sap Green + Manganese Blue (med.)
- **E** Permanent Rose + New Gamboge + French Ultramarine Blue = taupe (med.)
- **F** Raw Sienna (lt./med.)
- **G** Alizarin Crimson (med./dk.)
- **H** French Ultramarine Blue (lt./med.)
- **I** Raw Sienna + Permanent Rose (lt./med.)
- **J** Sap Green + Winsor Blue + Alizarin Crimson = pine green (dk.)
- **K** Alizarin Crimson + Winsor Blue (med./dk.)
- **L** Raw Sienna + Burnt Sienna (med./dk.)
- **M** Sap Green + Winsor Blue + Alizarin Crimson = pine green (med.)
- **N** Winsor Blue + Alizarin Crimson + Sap Green = brown/black (dk.)
- **O** Neutral Tint (med./dk.)

In this project, you will learn how to duplicate the look of glass by painting various reflective shapes of color and value. You will also learn how to paint a reflection mirrored against a dark and rounded object, as well as to paint a light-colored rose with both warm and cool shadows, and textured leaves.

Palette

New Gamboge (W&N)
Permanent Rose (W&N)
Sap Green (H)
Manganese Blue (H)
French Ultramarine Blue (W&N)
Raw Sienna (W&N)
Alizarin Crimson (W&N)
Winsor Blue (W&N)
Burnt Sienna (W&N)
Neutral Tint (W&N)

Brushes

no. 6 round, with a nice point
no. 8 round
no. 10 round

Other

A quarter-sheet (15" h x 11" w or 38.1cm x 27.9cm) Arches 300-lb., cold-press watercolor paper

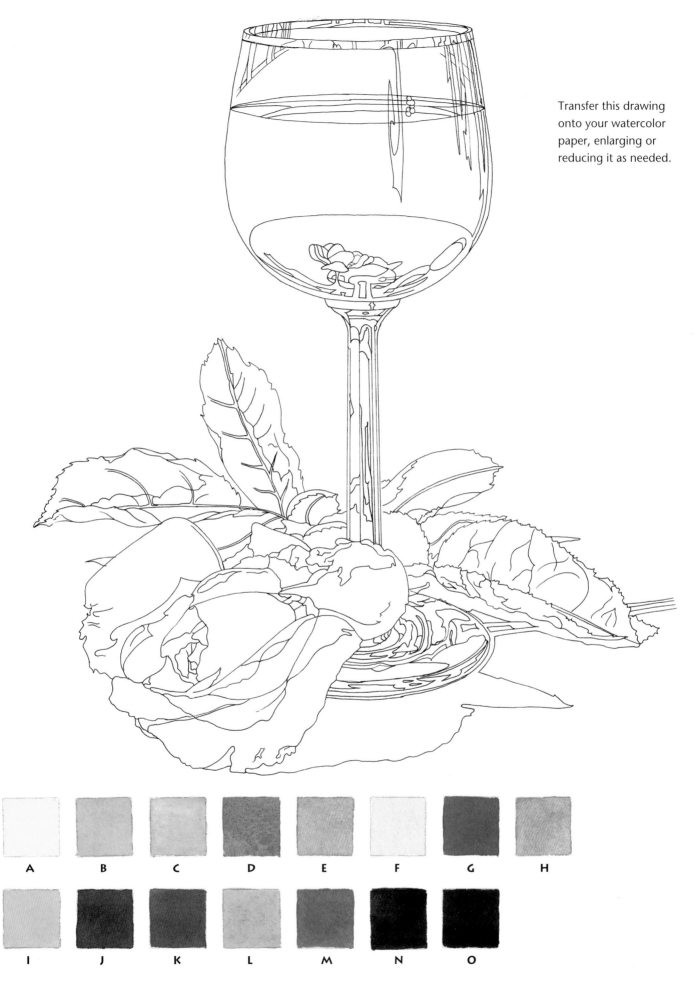

Transfer this drawing
onto your watercolor
paper, enlarging or
reducing it as needed.

A B C D E F G H

I J K L M N O

Underpainting color in the glass, rose petals and leaves

1. Paint the rose petals.

Mix colors **A** and **B**. Remove most of the graphite on your watercolor paper with your kneaded eraser. Load your brush with **A**, and paint all the yellow areas on the petals, softening some of the edges with water. Let each area dry completely before painting the one next to it. Rinse your brush and blot well. Load your brush with **B**, and paint all the pink areas on the petals, softening some of the edges with water. Let each area dry completely before painting the one next to it.

2. Paint the leaves.

Mix colors **B**, **C** and **D**. Paint the underside of the leaves first, one at a time. Load your brush with **B**, and paint along the leaves' outer edges. Quickly take a separate brush loaded with **C**, and charge **C** into **B**. Finish painting the rest of the leaves with **C**. While your wash is still moist, take a tissue and lightly blot out a few highlights. Let dry.

Paint the tops of the leaves next, using alternating charges of colors **B**, **C** and **D** as shown, rinsing your brush and blotting well between colors. Let each leaf dry before painting the leaf next to it.

3. Paint the glass.

Mix colors **B**, **C**, **D**, **E** and **H**. Load your brush with **H**, and paint all of those areas in the base and stem, softening some of the edges as shown. Paint the rest of the areas in the stem with **B**, **C** and **D**, using a brush that has a nice point, and charging some of the colors together as shown. Rinse your brush and blot well between colors.

Load your brush with **E**, and paint all those areas in the base, softening some of the edges with water as shown.

Remember to let each area dry completely before painting the one next to it.

Take a brush-load of **E**, and make a new puddle, adding enough water to make a very light value. Load your brush with the lighter value, and paint the area below the rim and above the wine line, being careful not to paint over the white highlights. Let dry. Paint the two areas with **F** as shown, soften with water.

4. Paint the reflection in the wine glass.

Mix colors **A**, **B** and **E**. Load your brush with clean water, and wet the area located below the wine-level line, and above the reflection line and to the left of the center highlight. Blot your brush well. Fully load your brush with **E**. When the sheen is almost gone, work quickly from the right side of the wine-level line to almost the bottom of the reflection and then work to the left side, allowing **E** to charge into the water. Blot your brush well.

Quickly dip your brush into **B**, and charge **B** into **E**. Paint a short distance to the left. Blot your brush well.

Quickly dip your brush into **A**, and charge **A** into **B**. Rinse your brush and blot well. Load your brush with **A** again, and paint a short distance. Soften all along the lower edge with a clean, moist brush. Let dry.

5. Paint the wine.

Mix color **G**. Load your brush with **G**, and paint the area shown in the wine, being careful not to paint over the white highlights. Let dry.

6. Paint the rim.

Mix colors **F** and **G**. Load your brush with **F**, and paint all the gold areas on the rim. Let dry. Rinse your brush and blot well. Load your brush with **G**, and paint the red area on the rim. Let dry.

7. Paint the cast shadow.

Mix colors **A**, **B** and **E**. Load your brush with **E**, and paint the stem's cast shadow and the shadows under the leaves. Let dry.

Paint the large cast shadow from the rose next. Fully load your brush with **E**. Starting on the right, paint to the left with **E** as far as the sample shows you to. Blot your brush well. Load your brush with **B** and charge **B** into **E**. Paint a small area. Blot your brush well. Load your brush with **A** and charge **A** into **B**. Finish painting the rest of the shadow. While the wash is still damp, take a clean moist brush and lift out a highlight and lift out along the front of the base as shown. Let dry.

TIPS

When painting the areas on the glass stem, try to keep your lines as straight as possible. If it's hard for you to paint a vertical line, try turning your board sideways and painting the lines horizontally.

When painting over the center highlight and reflection in the wine, try to keep your value as close to the sample as possible. If it comes out too light, go over it again until it comes close to the value shown. If you were to try to adjust the value at the end of your painting, the Alizarin Crimson may bleed color into the reflection.

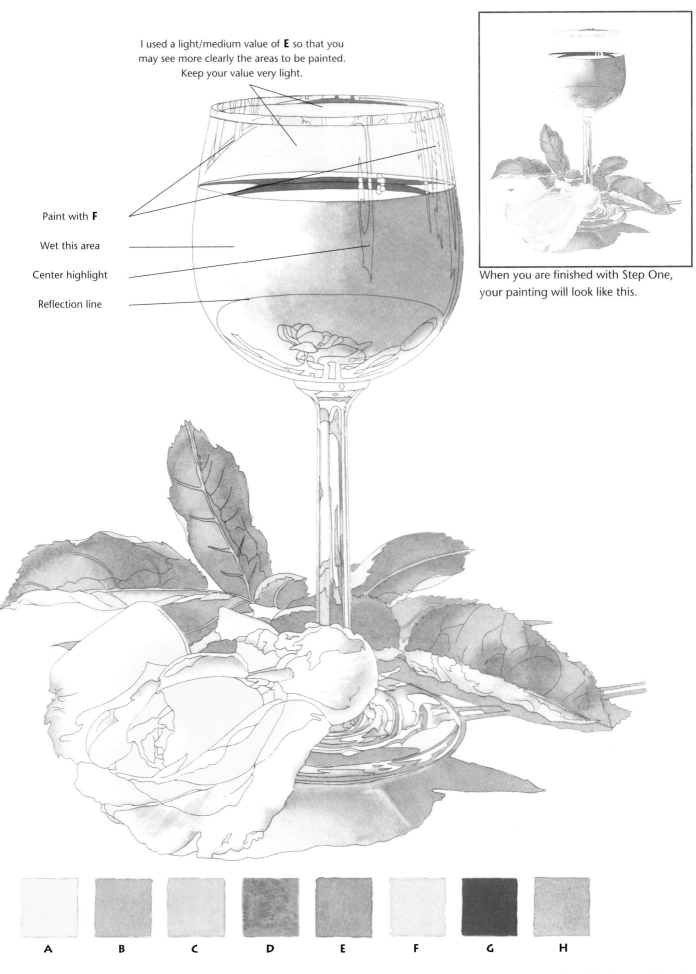

I used a light/medium value of **E** so that you
may see more clearly the areas to be painted.
Keep your value very light.

Paint with **F**

Wet this area

Center highlight

Reflection line

When you are finished with Step One,
your painting will look like this.

A B C D E F G H

STEP 2 Adding more color and shadows

1. Paint the warm and cool shadows in the petals.
Mix colors **A**, **B**, **C**, **E** and **I**. Load your brush with **I**, and paint all the warm shadows in the center of the rose, charging in with **A**, and also with **B** on the two lower areas as shown. Let each section dry before painting the one next to it. Rinse out your brush and blot well.

Load your brush with **C**, and paint those areas, softening the one edge with water. Rinse your brush and blot well.

Make a small lt./med. value puddle of **E**. Load your brush with the lighter value, and paint all the cool shadow areas, softening some of the edges with water as shown. Let dry.

2. Paint the shadows in the leaves.
Mix colors **D**, **E** and **J**. Load your brush with **J**, and paint the large shadows in the leaves, charging in with **D** on the areas shown.

Carefully go around the center and side vein lines, softening some of the areas with water as shown. Rinse your brush and blot well.

Paint the smaller shadows with **D** and **J**, softening the edges with water as shown. Rinse your brush and blot well.

Load your brush with **E**, and paint the shadow areas on the undersides of the leaves, softening the edges with water. Let dry.

3. Paint more detail in the glass.
Mix colors **D**, **E**, **H** and **J**. Load your brush with **E**, and paint all those areas in the stem and the base, softening the edges with water as shown. Let dry.

Load your brush that has a nice point with **J**, and paint along the lines and the small shapes in the stem and in the base, softening the one edge with water. Rinse your brush and blot well.

Paint the **D** and **H** areas next, charging in with **E** as shown. Remember to let each area dry before painting the one next to it. Rinse your brush and blot well.

4. Paint the rose and lighter shadows in the reflection.
Mix colors **A**, **B** and **E**. With **A** and **B** paint the rose reflection in the wine glass, letting each petal dry before painting the one next to it.

Load a brush that has a nice point with **E**, and paint the large shadow shapes and along some of the lines as shown. Let dry.

5. Paint the underlying color of the wine.
Mix colors **I** and **K**. Load your brush with **I**, and paint the area above the wine line, gently tickling along the red edge with your brush and allowing a little of the red color to bleed into **I**. Let dry. Rinse your brush and blot well.

Fully load your brush with **K**, and paint the area below the wine line, carefully going around the center and side highlights and the reflection. Let dry.

With **K** still in your brush, paint the area above the wine line. Let dry.

6. Paint more color on the rim.
Mix color **L**. Load a brush that has a nice point with **L**, and paint all the areas around the rim, softening some of the areas with water. Let dry.

7. Deepen the cast shadows from the rose and leaf.
Mix colors **E** and **J**. Load your brush with **J**, and paint along the bottom of the large leaf on the right. Blot your brush well. Quickly load your brush with **E**, and paint the rest of the leaf's cast shadow, charging **E** into **J**. Let dry.

Paint the large cast shadow from the rose next. Load your brush with **E**, and starting on the right, paint to the left with **E** as far as the sample shows you to. Rinse your brush and blot.

Quickly and gently charge the water from your brush into **E**, and finish painting the rest of the shadow with light brushstrokes and the water in your brush. When completely dry, take your scrubby brush and scrub out along the previous highlight, and along the front of the base.

TIPS

When painting the large area of wine in the glass, fully load your brush often to maintain a large bead for more even coverage.

Keep your shadow values light on the rose, as shown in the sample. Remember: It is easier to go back in to darken the shadows than it is to lighten them.

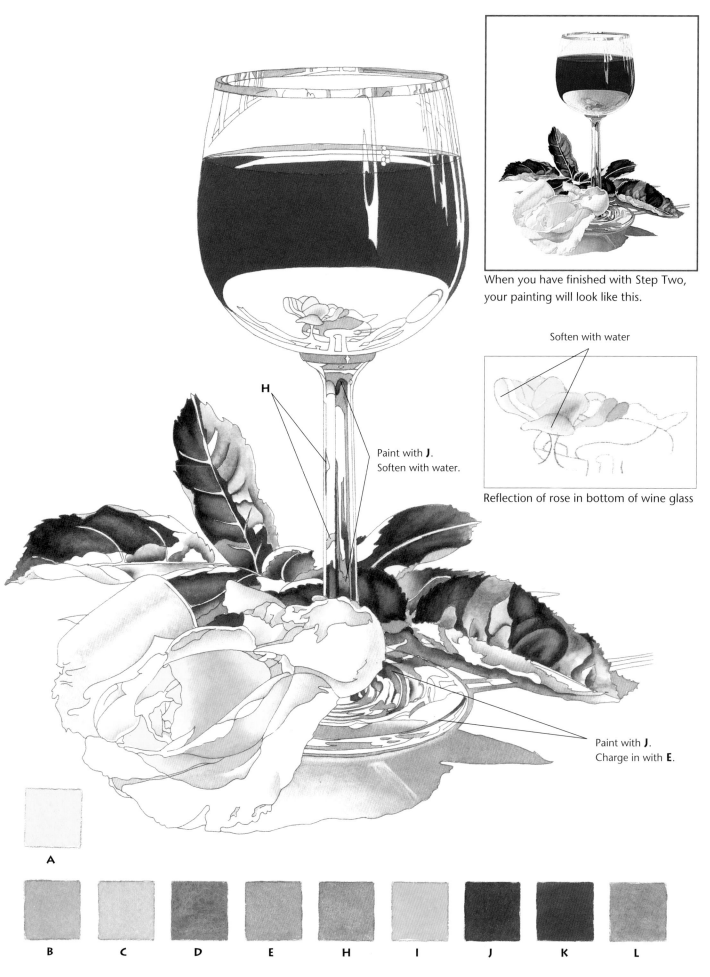

When you have finished with Step Two, your painting will look like this.

Soften with water

Reflection of rose in bottom of wine glass

H

Paint with **J**.
Soften with water.

Paint with **J**.
Charge in with **E**.

A

B C D E H I J K L

STEP 3 Add detail and color to the glass, rose petals and leaves

1. Add more color to the shadows on the petals. Mix colors **B**, **E**, **G**, **I**, and **L**. Load your brush with **I** and paint all of those shadows, softening with water as shown. Rinse your brush and blot well. Load your brush with **L**, and paint those areas, softening most of the edges with water. Let each area dry before painting the one next to it. Rinse your brush and blot well.

Load your brush with **B**, and paint those areas, charging in with **E** as shown. Let dry.

Load your brush that has a nice point with **G**, and paint along the edge that's curled under on the back petal, softening upwards with water. Let dry.

2. Glaze and outline the leaves. Mix colors **G** and **M**. Load your brush with **M**, and glaze over each dark shadow in the leaves, including over the center and side veins. Let dry. Load your brush that has a nice point with **G**, and outline along the outer edges and the center vein line shown in the sample. Let dry.

3. Paint the final shadows in the stem. Mix color **L** and **N**. Paint the areas at the top of the stem with **L** and **N**, softening the edges and lifting out a highlight as shown. Rinse your brush and blot well when changing colors.

4. Paint the darker shadows in the reflection. Mix colors **B**, **E**, **J**, **L** and **N**. Paint the shadows in the rose reflection with **B**, **E** and **L**, softening some of the edges with water. Rinse your brush and blot well between colors, and let each area dry completely before painting the one next to it.

Load your brush with **E**, and deepen the value of the glass shadows you painted in Step Two. Load your brush with **J**, and paint the reflection of the leaves, charging in **N** as shown. Let dry. Rinse your brush and blot well.

Load your brush with **N**, and paint all the dark shadows. Let dry.

5. Paint the final color of the wine. Mix color **O**. Fully load your brush with **O**. Starting slightly below the original wine-level line, paint over all the red areas, carefully going around the reflection and the center and side highlights as shown. Let dry. Paint the areas above the wine-level line, as shown. Let dry.

6. Paint the shadow shapes on the rim. Mix colors **L**, **M** and **N**. Load your brush that has a nice point with **M**, and paint those areas along the front of the rim, softening with water as shown. Let dry. Rinse your brush and blot well. Load your brush with **N**, and paint the rest of the dark shapes, charging in with **L**, and softening some of the edges with water.

TIP

When painting the wine area with color **O**, follow the same tip given in Step Two for that area. If you are unsure about your value of **O**, keep it on the lighter side. Otherwise, when it dries, it will take on a sheen that can occur when you have used too much pigment.

Leave bubbles white.

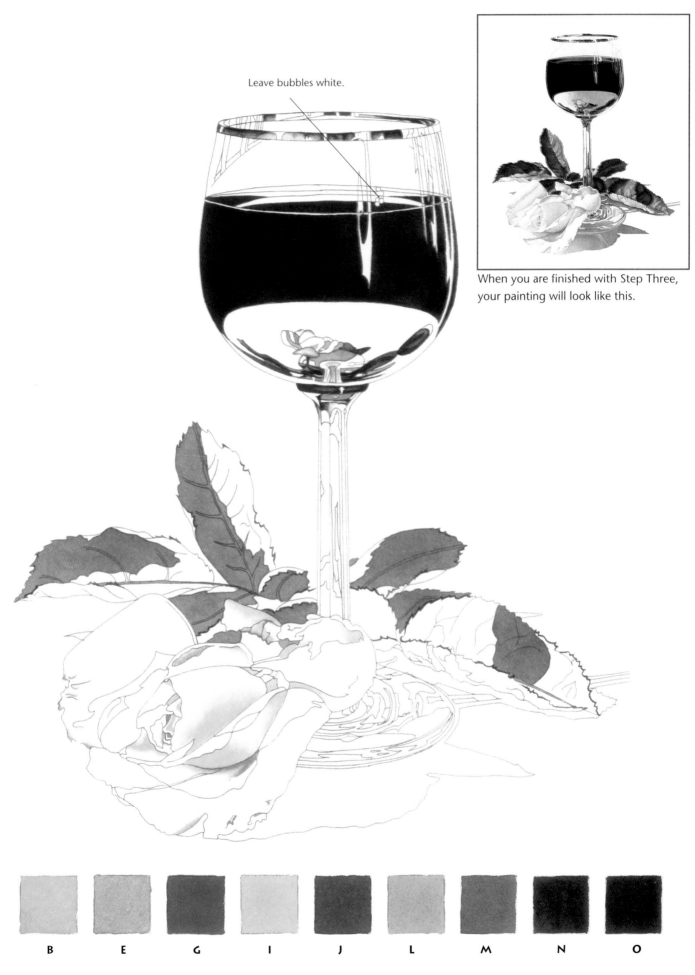

When you are finished with Step Three, your painting will look like this.

B E G I J L M N O

Finishing touches

Take a clean, moist brush and gently tickle some of the surrounding color over the white highlights in the wine area. With the same clean, moist brush, make a chisel edge, and lift out some of the color below and along the line that shows the wine level. Erase the pencil lines from the highlights.

Critique Your Work

Now that you have finished all the steps, compare your painting and its values to the finished project on the facing page. Take a look at your:

• Rose petals. If your values for the yellow areas around the center are too dark, try lifting some of the color first with a clean, moist brush. If that doesn't work, try gently scrubbing out some of the color with your scrubby brush. Let dry, then glaze with New Gamboge.

If your shadows got too dark, take a clean, moist brush and gently lift some of the color, then blot with a tissue. Let dry. If you lost your pink color, go back in and paint those areas again.

• Leaves. If the undersides of the leaves are too dark, take your scrubby brush and gently scrub some highlights into the leaves, and blot.

If there is not enough difference between the value of the leaves and the shadow areas on them, go back in and darken just the shadow areas.

• Glass. There should be both light and dark values in the stem and the base. If there aren't, go back in and deepen some of the values, and, possibly, lighten some.

• Reflection of the rose. Is there enough variation of color between the petals? If not, darken the shadow areas, or add more color. Do the same for the leaves and the base.

• Wine. If the value of the wine is too light, go back in and darken it with a lighter value of **O**. If the value is too dark or has a pigment sheen to it, it's best to leave it alone. Once your painting is matted and framed, you won't be able to see it.

• Gold rim. If your rim lost its circular design, load your brush with the color of the shape you want to straighten. Then blot your brush on a tissue, and lightly smooth out your jagged or crooked edge. If you lost your lights, take a tiny bit of an acrylic white paint and paint the areas that need to be light.

• Cast shadow. If your cast shadow from the rose got too dark, I would recommend just leaving it as is. Instead of trying to make it lighter, try to offset the darker value by adding darker values in the base, stem, and the shadows under the leaves.

If your shadow appears blotchy, load your brush with water. Starting at the back, paint the shadow areas again, lightly tickling over the blotchy areas. Finish painting the shadow with the watercolor in your brush. If your shadow by the rose got too dark, take a clean, moist brush and lift out some of the color, but do not blot.

Wine Glass and Rose
Dawn McLeod Heim
Watercolor on Arches
300-lb., cold-press
paper, 15" x 11"
(38.1cm x 27.9cm)

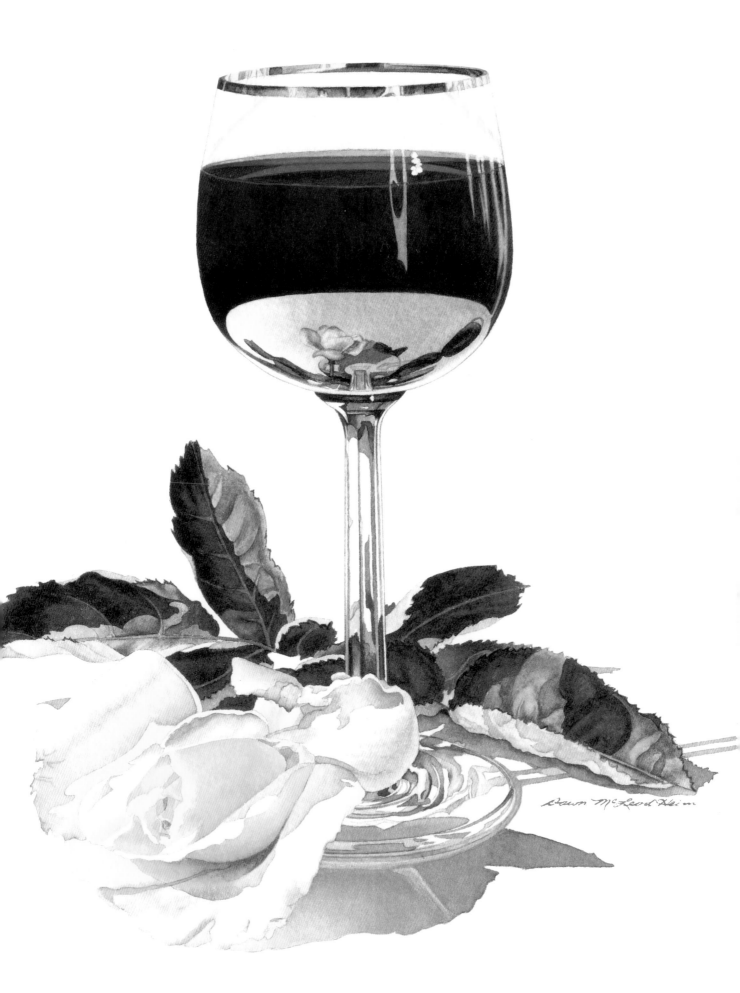

Snuggling Ducklings

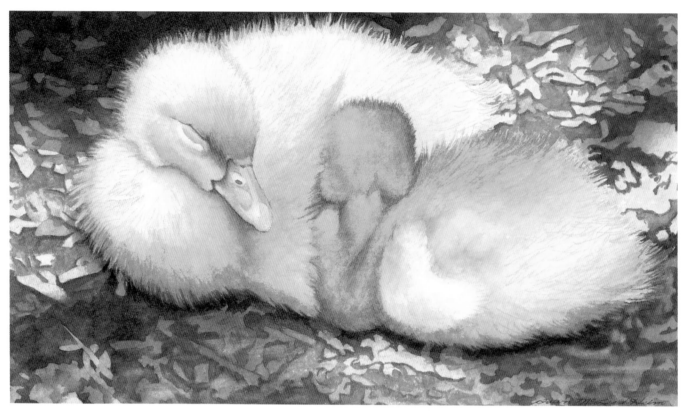

In this project, you will learn how to imitate the soft look of the fluffy down feathers found on these adorable baby ducklings. You will also learn how to add the look of texture to wood shavings, using overlapping brushstrokes, and blotting randomly with a tissue, while creating patterns of light in a background made up of abstract shapes.

Palette
Permanent Rose (W&N)
Permanent Brown (D.S.)
Indian Yellow (W&N)
Burnt Umber (W&N)
Burnt Sienna (W&N)
Sepia (W&N)
Cadmium Yellow (W&N)
Naples Yellow (W&N)

Brushes
no. 4 or no. 6 round, with a nice point
no. 8 round
no. 10 round
½ -inch (1.3 cm) flat

Other
An eighth-sheet (7 ½" h x 11" w or 19.0cm h x 27.9cm w) Arches 300-lb., cold-press watercolor paper

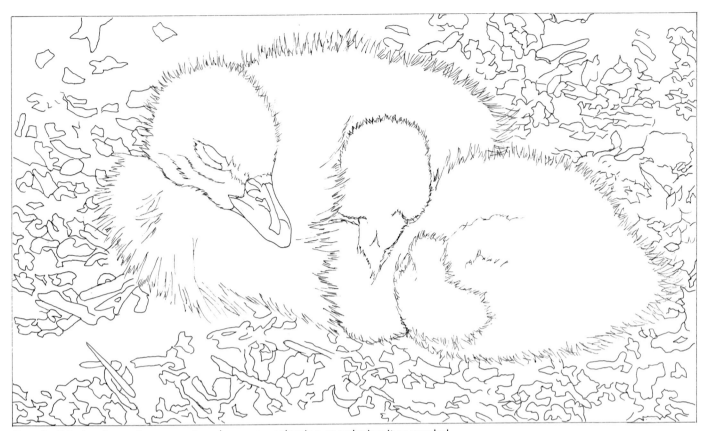

Transfer this drawing onto your watercolor paper, enlarging or reducing it as needed.

Color Key

A Permanent Rose + Permanent Brown (tad), (lt.)

B Indian Yellow (lt./med.)

C Burnt Umber + Permanent Brown (med.)

D Burnt Sienna + Indian Yellow (med.)

E Burnt Umber + Permanent Brown + Sepia = dark chocolate brown (med./dk.)

F Permanent Rose + Permanent Brown (med./dk.)

G Cadmium Yellow (med.)

H Naples Yellow (dk.)

STEP 1 Underpainting the fluffy feathers and background

1. Lighten and darken the graphite lines. With your kneaded eraser, lift up any heavy graphite from the ducklings. Make your lines as light as possible, leaving enough graphite so that they will still be visible after you have painted over them. With your pencil, go over all the lines in the background, but don't make them too dark.

2. Paint the beak. Mix color **A**. Load your brush with **A** and paint the beak, carefully painting around the areas that need to remain white, and softening the edges with water, as shown.

3. Paint the fluffy feathers on the duckling with a beak. Mix color **B**. Paint the head first. Load your brush with **B** and, starting at the beak, paint upwards along the eye line, and as far as the sample shows you to. Take a separate brush loaded with water, blot lightly, and soften upwards to the top of the head. Let dry. Paint the small area to the left of the beak in the same manner. Let dry.

With **B**, paint across the top of the chest and all the wing, softening the ends of the wing with water. Quickly take a separate brush loaded with water, blot lightly, then charge into **B**. Paint the rest of the chest with water. When you reach the ends of the fluffy feathers, switch to your brush that has a nice point, load it with **B**, and paint all the ends.

With **B** still in your brush, paint all the ends of the fluffy feathers across the top of the head and the back, working about ½" (1.3cm) at a time, and softening with water, as shown. Let dry.

4. Paint the fluffy feathers on the other duckling. Mix color **B**. Paint the head and chest areas first. Load your brush with **B** and, starting at the top of his head, paint down the back of his head, his neck, and then his chest, softening along the lower half of his wing with water, as shown. While your wash is still moist, carefully paint into the other duckling's wing, creating short, wispy strokes with your brush. Let dry.

With **B** still in your brush, paint across the top of the back and down, as far as the sample shows you to. Dip your brush that still has **B** in it into your clean water container, then slide the excess off your brush. Continue to paint the duckling with the lighter value of **B**. When you reach the wing, soften along the line as shown. Leave part of the wing white.

Finish painting the rest of the duckling with the lighter value. When you reach the ends of the fluffy feathers, switch back to the correct value of **B**, and paint the ends.

5. Paint the background. Mix colors **A**, **B** and **C**. Start painting the background at the upper right and paint clockwise. Load your brush with water, and wet the area shown in the sample. Blot your brush, then load it with **A**. Charge **A** into the water. Paint a short distance. Blot your brush well. Load your brush with **B**, and charge into **A**. Blot your brush well. Load your brush with **C**, and charge into **B**. Finish painting the top right corner with **C**.

Continue to paint the rest of the background with alternating charges of **A**, **B** and **C**. Some of the areas have water charged in. As you paint the background, tissue-blot the lighter areas when some of the sheen has gone.

TIP

If you happen to get any hard edges or any ballooning effects anywhere on the ducklings, don't worry. Let the area dry completely. Then take a clean, moist brush and gently tickle the color to even it out. Let dry.

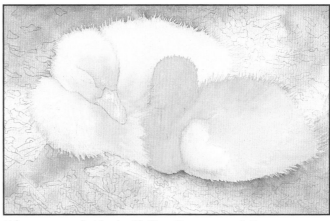

When you are finished with Step One, your painting will look like this.

Soften upwards with water from here

Soften with water

Wet this area with clean water

Charge with water

Soften along this line

Paint to here with **B**

A　　　**B**　　　**C**

STEP 2 Add shading and texture to the ducklings and the background

1. Add shading to the beak. Mix color **A**. Load your brush with **A**, and paint only the areas shown, softening along some of the edges with water.

2. Add shading and texture to the duckling with the beak. Mix colors **B** and **D**. Paint the head first. Load your brush with **D** and, starting at the beak, paint upwards and along the top of the eye line as shown. Rinse your brush and blot well.

Load your brush with **B**, and charge **B** into **D**. Paint a short distance. Take a separate brush, moist with water, and soften upwards as far as shown. Let dry.

Paint under the eye area next. Load your brush with **D**, blot once, and carefully paint around the white shape as shown. Quickly take a separate brush loaded with **B**, blot, then gently charge into **D**. Paint with **B** a short distance, switch back to **D**, and paint the area shown. Soften the edges with a clean, moist brush.

Load your brush with **D**, and paint a short distance across the top of the chest. Quickly take a separate brush loaded with **B**, and charge into the lower edge of **D**. Paint the same distance again, then soften with water. Repeat this across the chest and down the wing.

Charge **B** into the right side of the wing, and soften to the ends with water. Continue to paint upwards, causing with **B** to charge in with **D**. Soften with water.

Load your brush that has a nice point with **D**, and paint all the ends of the fluffy feathers along the top of the head and along the back, as previously done in Step One.

3. Add shading and texture to the other duckling. Mix colors **B** and **D**. Paint the head and chest areas first. Load your brush with **D** and starting on the top of the head, paint down the right side as far as shown. Quickly rinse your brush and blot. Load your brush with **B**, and paint the left side of the top of his head, charging **B** into **D**. Continue painting down the back of the head, then the neck, then the chest, with alternating charges of **B** and **D**, softening along the lower half of the wing.

Load your brush with **D**, and paint all along the back, softening toward the tail feathers with water.

While your wash is still moist, take a clean, moist brush, and randomly lift out color, creating short, wispy strokes. Let dry.

With **D** still in your brush, paint all the ends of the fluffy feathers on the underside of the duckling, softening upwards with water. Let dry.

4. Add shading and texture to the background. Mix colors **C** and **E**. Start the background at the upper right again and paint clockwise as before. Load your brush with **C**, and paint the lighter brown areas, using short, overlapping brushstrokes and working your way around the white shapes. Randomly blot with a tissue, then deepen some of the values by using overlapping brushstrokes on the areas you just painted; again randomly blot with a tissue. You want to create as much texture as possible.

When you reach the darker brown areas, charge in with **E**, repeating the same method for creating texture. The upper left is all painted with **E**. When you get near the ends of the ducklings' fluffy feathers, switch to a brush that has a nice point, and create short, wispy strokes between the ends.

TIP

On the smaller areas around the face, you may want to blot your brush once lightly on a tissue before painting, even on the colors that you are charging in with. That way, the color you are charging in with will not take over and dominate the color you previously painted.

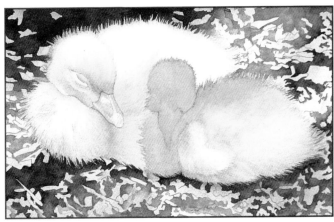

When you are finished with Step Two, your painting will look like this.

Soften to here
with water

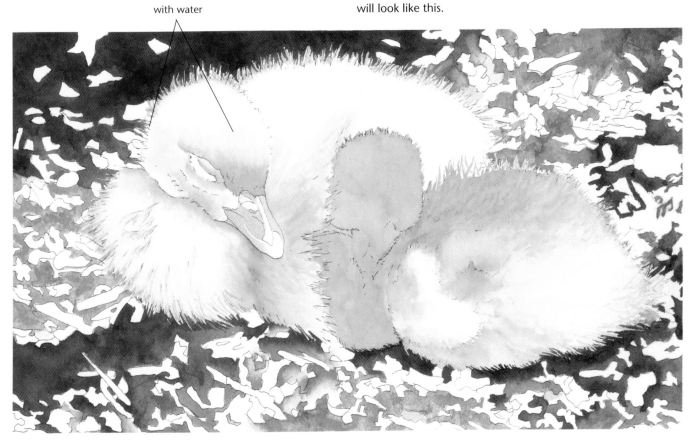

A B C D E

Final shading and texturing of ducklings and background

1. Add final shading to the beak. Mix colors **A**, **C** and **F**. Load your brush with **A**, and paint the light pink areas, softening some of the edges with water, as shown. Let dry. Load your brush that has a nice point with **C**. Quickly paint all along the top of the beak. Keep the edge moist. Blot your brush well. Quickly load your brush with **F**, and charge into **C**, then soften the edge with water. Let dry. Paint the nostril hole with **F**.

2. Add the final shading and wispy feathers to the duckling with a beak. Mix colors **B**, **C**, **D** and **G**. Paint the head first. Load your brush with **G** and, starting at the beak, paint upwards and along the top of the eye line. Soften upwards with water. Let dry.

Load your brush with **D**, and paint the area that separates the head from the chest. Rinse your brush and blot well. Load your brush with **G**, and charge into **D**. Soften upwards a short distance with a clean, moist brush. Let dry.

Load your brush that has a nice point with **C**, blot, and paint the narrow area under the eye line, using very tiny brushstrokes. Look closely at the sample.

Load your brush with **D**, and paint across the top of the chest, softening the edge with water. Let dry.

Paint the area directly under the beak next. Load your brush with **C**, and paint a short distance. Blot your brush well. Load your brush with **C**, and charge into **D**. Paint a short distance. Rinse your brush and blot well. Load your brush with **G**, and charge into **C**.

Paint the area to the left and the wing with **G**, softening the chest and the ends of the wing with water. Let dry.

With **G** still in your brush, use wispy brushstrokes to paint tail feathers. Load your brush that has a nice point with **D**, and blot. Dip the tip of the brush into **B** and, using wispy brushstrokes, paint the individual feathers on the top of the head, the chest, and the areas shown on the back. Let dry. Take a separate clean, moist brush, and randomly soften across the feathers you just painted.

3. Add the final shading and wispy feathers to the other duckling. Mix colors **B**, **C**, **D**, **E** and **G**. Paint the head and chest areas first. Load your brush with **C**, and paint the area on the upper-right side of the head. Rinse your brush and blot well. Load your brush with **D**, and paint the upper middle of the head, charging into **C**. Rinse your brush and blot well. Load your brush with **G**, and paint the upper left of the head, charging into **D**. Soften all three of the colors down the back of the head with water.

Looking at the sample, paint the rest of the neck and chest areas with **C**, **D** and **G**, softening with water. Let dry.

Load your brush that has a nice point with **E**, and paint the small area to the left of the head. Soften with water. Load your brush with **D**, and paint the two areas above the wing, softening with water as shown. Let dry.

Load your brush that has a nice point with **D**, and blot lightly. Paint all the feathers across the top of the back using the same wispy brushstrokes. Let dry.

With **D** still in your brush, dip the tip of your brush into **B**, and paint the wispy feathers near the tail, as shown. Rinse your brush and blot well.

Load the same brush with **G**, and paint the wispy tail feathers. When dry, take a clean, moist brush and randomly soften over all the wispy feathers.

4. Add the final shading and texture to the background. Mix colors **C** and **E**. Start painting the background at the upper right and paint clockwise. Load your brush with **C**, and paint some of the lighter brown areas. Take a separate brush loaded with water, and charge into **C**. Paint with the water brush for a short distance, then charge back into the wet area with **C**. Charge **E** into the darker areas. When the sheen is almost gone, take a tissue and firmly blot the lighter areas. Continue to paint the background with **C** and **E**, and to charge water and tissue-blot the lighter areas.

When completely dry, load your brush with **E**, and paint the shadow lines at the upper right and to the left of the duckling with a beak. With **E** still in your brush, paint the dark shadow under both of the ducklings, carefully going in between the ends of the fluffy feathers, and softening with water all along the bottom edge of the shadow. Let dry. Rinse your brush and blot well.

Load your brush with **C**, and paint the shadow lines in front of the ducklings. Let dry.

TIP

When painting the wispy feathers on both ducklings, keep the lines narrow, and stroke your brush upwards and away—not downward toward yourself—using a quick motion. Try to not make them straight. Look closely at the sample to see the different directions.

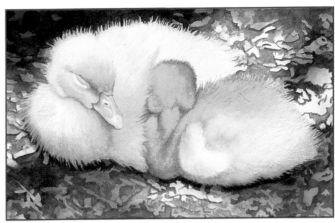

When you are finished with Step Three, your painting will look like this.

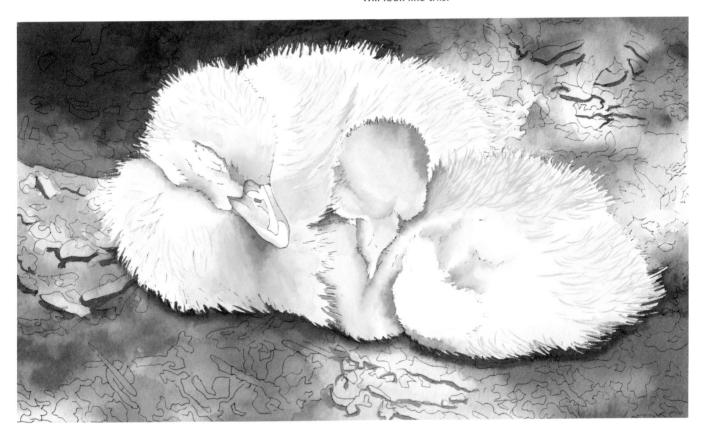

A B C D E F G

STEP 4 Finishing touches

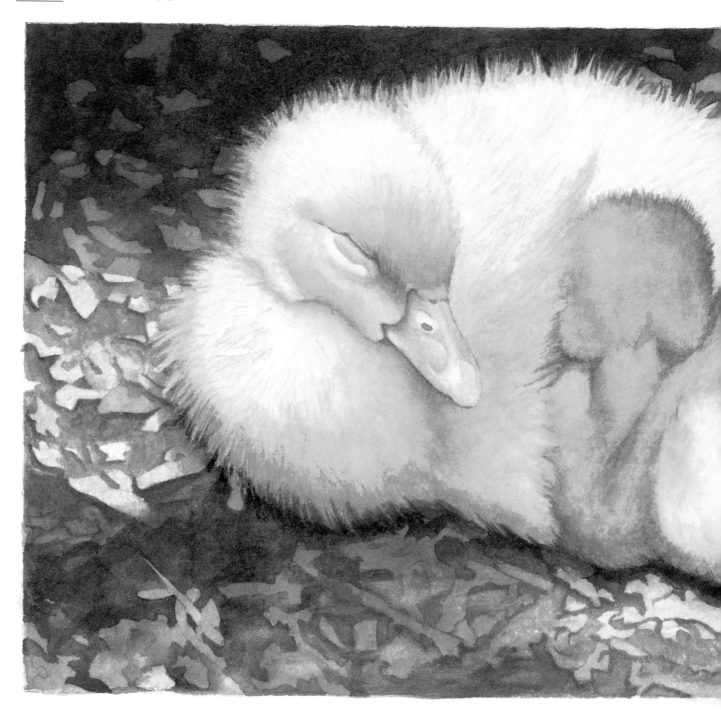

Load your brush that has a nice point with **H**. Using short, wispy brushstrokes, randomly paint between all the ends of the fluffy feathers across the head, back and chest of the duckling with a beak.

Critique Your Work

Now that you have completed all the steps, compare your painting and its values to the finished painting at left. Take a look at your:

• Duckling's beak. If the values are too dark, try lifting some of the color with a clean, moist brush, then blotting with a tissue. If that doesn't work, gently scrub some of the color out, using your scrubby brush, then blot. If some of the areas are too light, glaze over the areas with more color.

• Ducklings' fluffy down feathers. If your values are too dark, take a clean, moist brush and lift out some of the color, then blot with a tissue. If that doesn't work, lightly scrub out the color.

If after you have lightened the value, your ducklings appear dull, glaze over the fluffy feathers with Cadmium Yellow and soften with water.

If some areas still need to be darkened, go back in with the shading colors and deepen the value.

• Background. If you have lost your patterns of light, take your scrubby brush and lighten some of the areas. If areas need to be darkened, go back in with the color you're using for that particular area, and deepen the value. If the wood chips lost their texture, go back in and repeat Step Two, matching their appearance to the finished painting at left.

Snuggling Ducklings
Dawn McLeod Heim
Watercolor on Arches
300-lb., cold-press
paper, 7½" x 11"
(19cm x 28cm)

Vegetables on a Cutwork Cloth

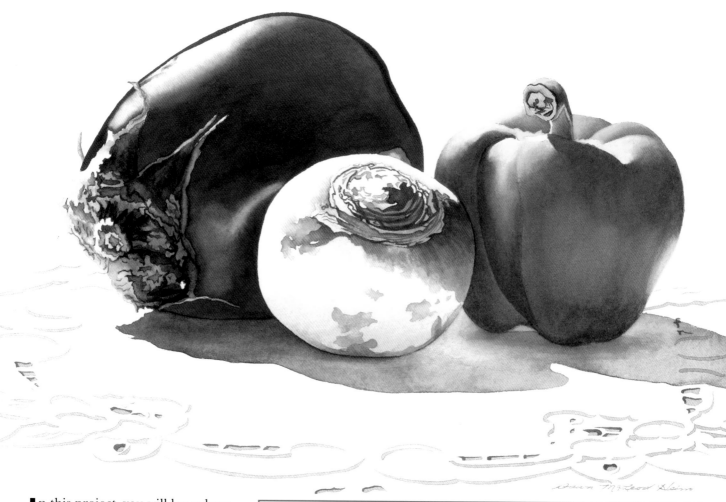

In this project, you will learn how to paint vegetables that have differently textured surfaces. For the smooth and shiny vegetables like the eggplant and the pepper, you will be using layered washes of transparent staining color. For the turnip, you will be using mainly nonstaining colors.

You will also learn how to enhance a cast shadow by using various colors from your subject matter, as well as how to duplicate the thickness of a cutwork cloth and create the illusion of holes by painting just the shadow shapes in the pattern.

Palette
Burnt Umber (W&N)
Permanent Rose (W&N)
Carbazole Violet (D.S.)
Sap Green (H)
Winsor Blue (W&N)
Carmine (D.S.)
Green Gold (D.S.)
Hooker's Green Light (W&N)
Sap Green (D.S.)
Permanent Brown (D.S.)
New Gamboge (W&N)
French Ultramarine Blue (W&N)

Brushes
no. 4 round, with a nice point
no. 6 round, with a nice point
no. 8 round
no. 10 or no. 12 round
small scrubby brush

Other
A quarter-sheet (11"h x 15"w or 27.9cm h x 38.1cm w) Arches 300-lb., cold-press watercolor paper

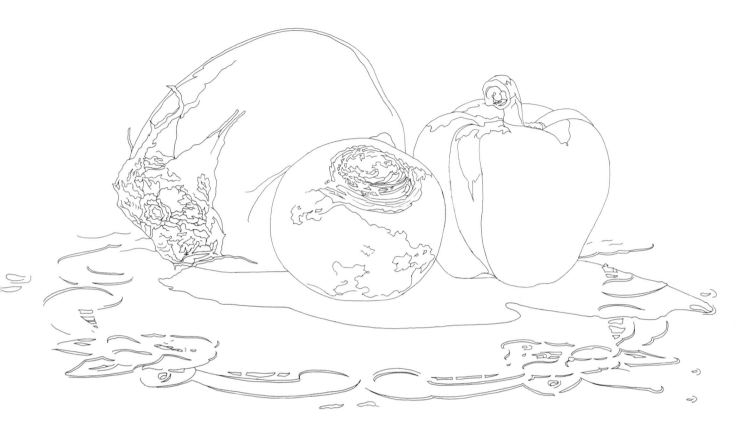

Transfer this drawing onto your watercolor paper, enlarging or reducing it as needed.

Color Key
A Burnt Umber (lt./med.)
B Permanent Rose + Carbazole Violet (tad), (med.)
C Sap Green (H), (med./dk.)
D Winsor Blue + Carbazole Violet (med.)
E Carmine + Winsor Blue (med./dk.)
F Green Gold (med.)
G Hooker's Green Light (med.)
H Permanent Brown + Carbazole Violet (med.)
I Sap Green (H) + French Ultramarine Blue (dk.)
J Sap Green (D.S.), (med.)
K Hooker's Green Light + Sap Green (D.S.), (med.)
L French Ultramarine Blue + Permanent Rose (tad) + New Gamboge (tad) = a grayed blue (med.)

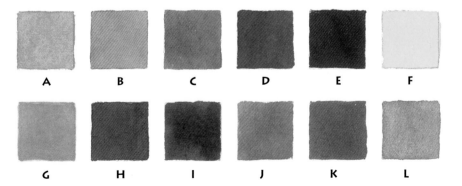

Underpainting color and texture in vegetables, and holes in the cloth

1. Paint the turnip. Mix colors **A** and **B**. Take a brush-load of **A**, and make a new puddle, adding enough water to make a light value. Fully load your brush with the light value, and paint across the bottom of the turnip. Soften the upper edge with water. Continue softening upwards until your wash is clear. Quickly load your brush with **A**, and apply a continuous brushstroke of color along the bottom edge, allowing the color to gently charge upwards. Let dry.

With **A** still in your brush, paint the brown spots and all the brown areas on the top, softening some of the edges, as shown. Rinse your brush and blot well.

Load your brush with **B**, and paint all the pink areas, softening some of the edges, and touching the damp wash randomly, making the surface appear blotchy.

Load your brush that has a nice point with **B**, and paint all the narrow areas on the top.

2. Paint the eggplant. Mix colors **A**, **C**, **D** and **E**. Paint the purple-and-blue areas of the eggplant twice. Load your brush with **A**, and paint the center area of the stem. Let dry. Load your brush with **C**, and paint all the green areas, charging in with water to vary the value. (Some areas have **A** charged in.) Let dry. Rinse your brush and blot well.

Load your brush with clean water, and wet the area along the top of the eggplant, as shown. Fully load your brush with **D** and, when the sheen is almost gone, paint the blue area at the upper right, and along the lower right edge of the water, allowing **D** to gently charge upwards. Immediately blot your brush well, fully load it with **E**, and continue painting along the lower edge of the water, allowing **E** to gen-tly charge upwards. Blot your brush.

Fully load your brush again, and continue painting the eggplant, using light brushstrokes in a back-and-forth motion similar to that of a windshield wiper, pause often to fully load your brush. Carefully paint around the reflection of the green pepper.

When you reach the reflection of the turnip, take a separate brush that is loaded with **A**, and gently charge **A** into **E**. Switch back to your brush that is loaded with **E**, and finish painting the rest of the egg-plant. While your wash is still damp, take a clean, moist brush, and light-ly lift out a large highlight to the left of the turnip. Let dry. Repeat this step again.

3. Paint the pepper. Mix colors **A**, **F** and **G**. The yellow-and-green areas of the pepper are painted twice. Load your brush with **A**, and paint the end of the stem. Let dry. Paint the rest of the stem and the upper-back sections of the pepper next. Load your brush with **F**, and paint as far as shown. Rinse your brush and blot well. Load your brush with **G**, and charge into **F**. Finish paint-ing the rest of the section with **G**, allowing it to dry before painting the section next to it.

Divide the large areas in the front into three sections. Paint the one on the left first. Load your brush with **F**, and paint a small area below the white highlight. Blot your brush well. Fully load your brush with **G**, and quickly paint the rest of the section, maintaining a large bead and loading your brush often. Paint the section on the right next. Load your brush with **F**, and quickly paint the areas on the upper left and upper right, then cover the large area in the middle with water. Keep moist. Blot your brush well.

Fully load your brush with **G**. Start directly below the stem and quickly paint downwards and across the top area, allowing **G** to charge into the lower wet edges of **F**, using slightly overlapping brushstrokes. Work quickly down to the middle area that has been made wet with water. Quickly paint down the left side of that section and along the bottom of the pepper.

Go back up to your wet edge and, with light brushstrokes, paint over the center section. Paint to the bot-tom of the pepper with the light-ened value of **G**. Do not reload your brush. Mop up any excess color. Let dry.

Paint the middle section next. Load your brush with **F**, and paint a small area below the highlight. Blot your brush well. Quickly load your brush with **G** and finish painting that section. Let dry. Repeat this step again to deepen the values.

4. Paint the cloth. Mix color **A**. Load your brush with **A**, and paint all the hole shapes shown in the sample.

TIPS

If too much color charged into the water area along the top of the eggplant, try lifting out some of the color while the wash is still damp. Otherwise, wait until both Steps One and Two on the egg-plant have been painted, then gently scrub out some of the color using your scrubby brush.

When you are painting the green areas on the pepper, try to paint them quickly. Hooker's Green Light is a highly staining color that locks color into your paper instantly. If you are not familiar with this color, I recommend practicing with this color on a scrap piece of water-color paper first.

When you are finished with Step One, your painting will look like this.

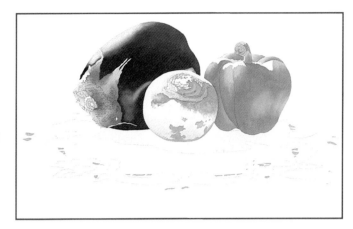

Apply a wide band of water along here

Paint from here to here with **D**

Leave white

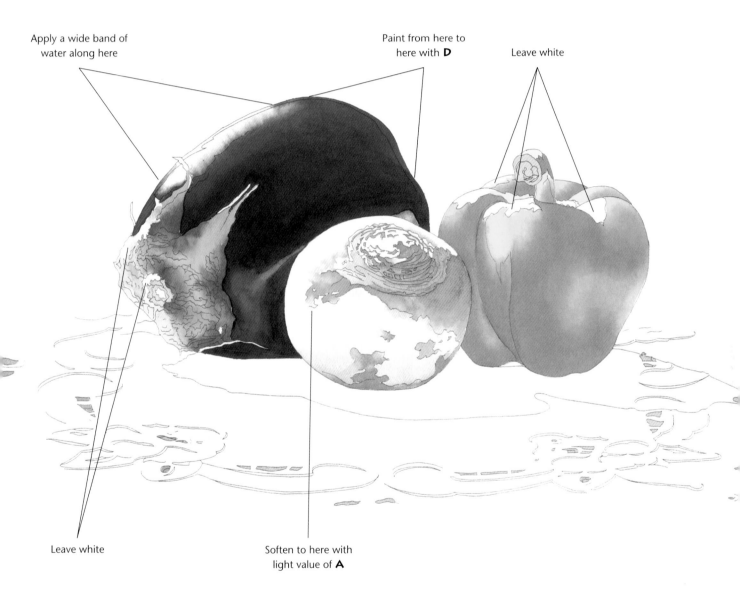

Leave white

Soften to here with light value of **A**

A	B	C	D	E	F	G

Deepen values in vegetables; paint the cast shadows and the cloth pattern

1. Paint the turnip. Mix colors **A**, **B**, **C** and **H**. Load your brush with **A**, and paint the areas at the bottom of the turnip. Rinse your brush and blot well. Load your brush with **C**, and paint those areas.

Load your brush with **B**, and paint all the pink areas on the top, charging in with **H** on some of the areas, and softening the edges as shown. Rinse your brush and blot well.

Load your brush that has a nice point with **H**, and paint along the lines shown in the samples for the top of the turnip.

2. Paint the eggplant. Mix colors **E**, **H** and **I**. Load your brush with **E**, and paint the area between the line and the outer edge along the top of the eggplant, softening the lower-right edge with water, lightly glazing over the reflection of the pepper. When completely dry, paint the same area again; this time, do not glaze over the reflection of the pepper. Rinse your brush and blot well.

Load your brush with **I**, and paint all the green areas, softening the edges, as shown in the sample. Let dry. Rinse out your brush and blot well.

Load your brush with **H**, and paint all those areas, softening most of the edges as shown.

3. Paint the pepper. Mix colors **H**, **J** and **K**. Paint the stem and all the upper-back sections of the pepper first. Load your brush with **J**, and paint as far as the sample shows you, then soften with water. Let each section dry before painting the one next to it.

Using light brushstrokes, paint the front sections of the pepper in the same manner as in Step One, but with **J** and **K**. Charge the colors together, as shown. Let dry. Load your brush that has a nice point with **H**, and outline the areas on the top of the stem, softening some of the edges.

4. Paint the cast shadow. Mix colors **B**, **C**, **E**, **H**, **I**, **K** and **L**. Paint the complete shadow, working from left to right. Start under the eggplant and charge the colors, using continuous overlapping brushstrokes in the following order: under the eggplant: **C**, **H**, **E**, **I** and **B**; under the turnip: **C**, **B** and **L**; under the pepper: **C**, **K**, **C** and **L**.

When completely dry, load your brush with **H**, and paint the shadow again just under the eggplant and the turnip, softening the edge outwards with clean water. Rinse your brush and blot well.

Load your brush with **K**, and paint under the pepper a short distance. Dip the tip of your brush into **H**, and paint under the rest of the pepper with the **K-L** combination. Soften the edge outwards with clean water.

5. Paint the shadows in the cloth. Mix colors **H** and **L**. Load your brush with **H**, and paint all the shadows in the holes. Rinse your brush and blot well. Load your brush with **L**, and paint all the areas between the lines on the cloth's pattern.

TIPS

When painting the pepper, remember to work quickly, because of the highly staining character of Hooker's Green Light.

After rinsing your brush between colors in the cast shadow, blot your brush well to prevent any unwanted ballooning effects.

Top of Turnip

Step 1. Paint these areas with **H**. Let dry.

Step 2. Soften the edges with a clean, moist brush.

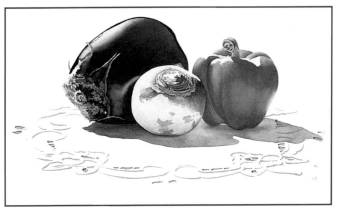

When you are finished with Step Two, your painting will look like this.

Line Outer edge

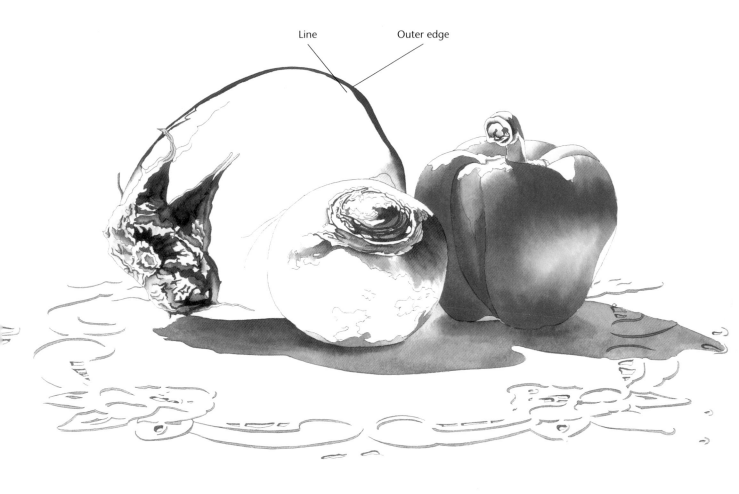

A B C E H I J K L

STEP 3 Finishing touches

Soften the highlighted areas on the pepper by lightly scrubbing out the line that separates the white highlight from the yellow-green areas; use short brushstrokes to do this. Scrub just a few strokes at a time, and blot each time you scrub. Make sure you rinse your scrubby brush often so that you do not scrub the color back into the area you are trying to lift the color from, especially the white areas. Scrub into the colored area as shown in the finished painting above, brushing in the direction of the roundness of the pepper and blotting lightly. You want to expose some of the Green Gold and Hooker's Green Light colors that are underneath.

Critique Your Work

Now that you have completed all the steps, compare your painting and its values to the finished painting at right. Take a look at your:

• Turnip. If the brown color took over your pink and dulled it, lightly scrub out the dulled color, let dry, then glaze over the pink area with a light value of Opera, which is a slightly opaque, bright pink color made by Holbein. This will help punch up the color. The dark brown areas should be really dark. If they aren't, go back in and darken them.

• Eggplant. If your value is too light, repeat the layering process with the purple and blue colors until it closely matches the value in the painting at left.

If you lost your white highlight along the top, take your scrubby brush and gently scrub out the color, blotting with a paper towel, not a tissue. (A tissue will leave lint particles on the dark pigment.)

If you lost your lighter green areas in the front, take a clean, moist brush and gently tickle the color, then blot with a tissue.

The brown areas should be very dark for contrast. If they are not dark enough, paint them again, but use a lighter value.

• Pepper. If you feel that you have overworked the shadow color on your pepper, or have gotten it too dark or gummy looking, take a clean, moist brush, and lift off all the shadow color, blotting with a tissue. The Hooker's Green Light will still be visible because of its staining power. Let dry completely. Then go back and paint with the shadow colors again, using light brushstrokes.

• Cast shadow. If your shadow got too dark, lift out some of the color near the turnip and the pepper, then blot. The shadow color by the eggplant can remain dark.

If you feel that your shadow is too blotchy and spotty, take a brush fully loaded with water and paint over the entire shadow, tickling the areas that are blotchy or spotty, and finish painting the shadow. Let dry.

• Cloth. If your values do not look like the ones in the painting at left, adjust them accordingly.

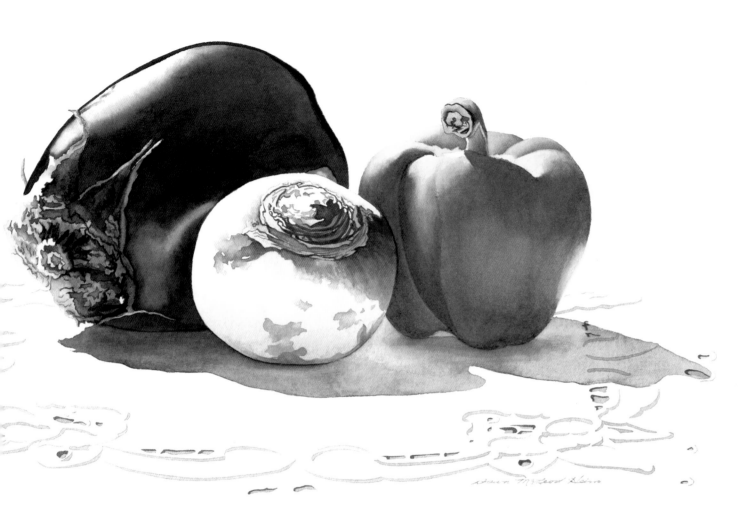

Vegetables on a Cutwork Cloth
Dawn McLeod Heim
Watercolor on Arches
300-lb., cold press paper
11" x 15"
(27.9cm x 38.1cm)

Teacup With a Gold Spoon

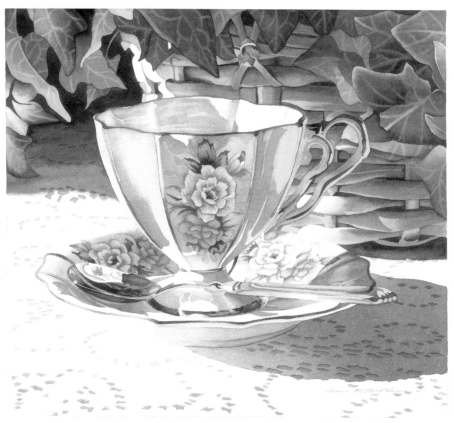

Color Key
A New Gamboge (lt.)
B Permanent Rose (lt.)
C Cerulean Blue (lt.)
D Yellow Ochre (med.)
E Raw Sienna + Carmine (tad), (med./dk.)
F Sap Green (med.)
G Sap Green + Winsor Blue (med./dk.)
H Sap Green + Winsor Blue + Carmine = pine green (med./dk.)
I Carmine + Burnt Sienna (lt./med.)
J French Ultramarine Blue + Permanent Rose + New Gamboge = light warm gray (med.)
K Raw Umber + Burnt Sienna (med./dk.)
L Permanent Brown + Sap Green (med.)
M French Ultramarine Blue + Permanent Rose + New Gamboge = dark warm gray (med./dk.)
N Carmine (med./dk.)
O Cerulean Blue (med./dk.)
P Cerulean Blue + Carmine + New Gamboge = chalky purple gray (med./dk.)
Q Permanent Brown + Sap Green (dk.)
R Permanent Brown (med.)
S Cerulean Blue + Payne's Gray (med./dk.)

In this project, you will learn how to simulate the shimmering appearance of the mother-of-pearl finish on this antique teacup and saucer, as well as how to paint the same flower pattern in sunlight and in shadow. You will also learn how to create veins in leaves by lifting out color while the wash is still damp, how to paint a woven basket, and how to imitate the reflective look of gold.

Palette
New Gamboge (W&N)
Permanent Rose (W&N)
Cerulean Blue (W&N)
Yellow Ochre (W&N)
Raw Sienna (W&N)
Carmine (D.S.)
Sap Green (H)
Winsor Blue (W&N)
Burnt Sienna (W&N)
French Ultramarine Blue (W&N)
Raw Umber (W&N)
Permanent Brown (D.S.)
Payne's Gray (W&N)

Brushes
no. 6 round, with a nice point
no. 8 round, with a nice point
no. 10 round
small scrubby brush

Other
A quarter-sheet (11" h x 15" w or 27.9cm h x 38.1cm w) Arches 300-lb., cold-press watercolor paper

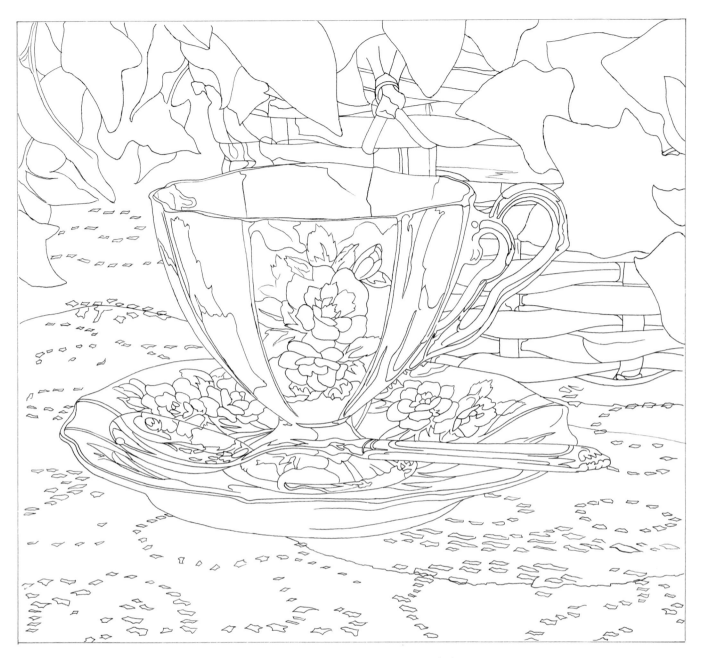

Transfer this drawing onto your watercolor paper, enlarging or reducing it as needed.

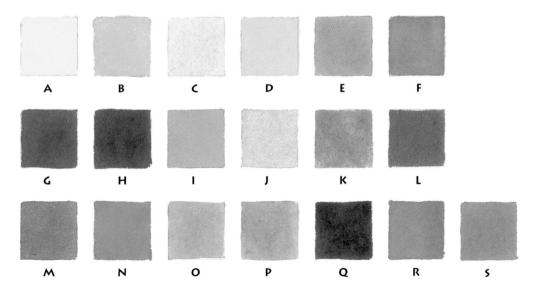

A

B

C

D

E

F

G

H

I

J

K

L

M

N

O

P

Q

R

S

STEP 1 Underpainting the teacup, gold spoon, leaves, basket and holes in the cloth

1. Paint the mother-of-pearl finish on the teacup. Mix colors **A**, **B** and **C**. Paint the inside of the teacup first, starting on the far left side. Load your brush with **B**, and paint the small area, gently charging in with **C**. Soften with water to the line, as shown. Let dry.

Paint the next section. Load your brush with **C**, and paint a small area. Rinse your brush and blot well. Load your brush with **A**, and gently charge into **C**. Paint a small area as shown in the sample. Rinse your brush and blot well.

Load your brush with **B**, and gently charge into **A**. Paint the small area as shown. Continue charging the colors in the order shown on the sample, softening with water.

Next, paint the areas on the handle, charging the colors as shown. Let dry.

Paint all the front areas of the teacup in the same manner, but lighten the value by charging in with alternating brushstrokes of water. Let dry.

2. Paint the gold edging on the teacup. Mix color **D**. Load your brush that has a nice point with **D**, and paint all the gold edging on the teacup and the saucer. Let dry.

3. Paint the gold spoon. Mix colors **D**, **E** and **F**. Load your brush that has a nice point with **D**, and paint along the line in the round portion of the spoon. Soften that edge. Let dry. Paint along the solid line next to it. Do not soften the edge. Let dry.

With **D** still in your brush, paint the other areas in the round portion of the spoon and along the handle, softening the two areas with water. Rinse your brush and blot well.

Load your brush with **E**, and paint the underside of the round portion of the spoon. Let dry. Rinse your brush and blot well.

Load your brush with **F**, and paint the green area. Let dry.

4. Paint the basket. Mix colors **D** and **E**. Paint the basket from left to right with alternating charging in of **D** and **E**. Load your brush with **D**, and paint the small areas on the far left first. Now fully load your brush with **D**, and paint as far as the sample shows you to. Rinse your brush and blot well.

Fully load your brush with **E**, and charge **E** into **D**. Paint as far as shown. Repeat the charging of **D** and **E** until the basket is completely painted, softening the two areas with water, as shown. Let dry.

5. Paint the leaves and lift out veins. Mix colors **F**, **G** and **H**. Paint all the single-colored leaves first. Load your brush with **F**, and paint one of the light-green leaves. When the sheen is almost gone, take a separate clean, moist brush and lift out along the vein lines, as shown in the sample. Finish painting all the **F** leaves, charging in with water on the lighter colored ones. Rinse your brush and blot well.

Load your brush with **G**, and paint all those leaves in the same manner as the light-green leaves. Repeat with **H**.

Paint the rest of the leaves by matching the colors in the sample against the colors in the color bar. Most of the leaves have two colors charged together. Soften the lighter areas on the leaves with water. Let each leaf dry before painting the one next to it.

6. Paint the lace holes. Mix color **I**. Paint the holes to the upper left of the teacup first. Load your brush that has a nice point with **I**, and paint all the holes behind the back shadow line, along the shadow line, and in the cast shadow. Paint all the light-colored holes next, immediately blotting each one firmly with a tissue. Then paint the holes across the front of the painting, blotting each one lightly with a tissue.

TIPS

When you are painting the mother-of-pearl finish on the teacup, keep your values light. I used a light/medium value in the sample at right so you could more easily see where the different colors are placed.

Keep your colors clean by rinsing and blotting well between charging of colors. If your colors are charging too quickly, try blotting the tip of your brush lightly on a tissue immediately after loading your brush, to help remove any excess color.

When you are
finished with Step
One, your painting
will look like this.

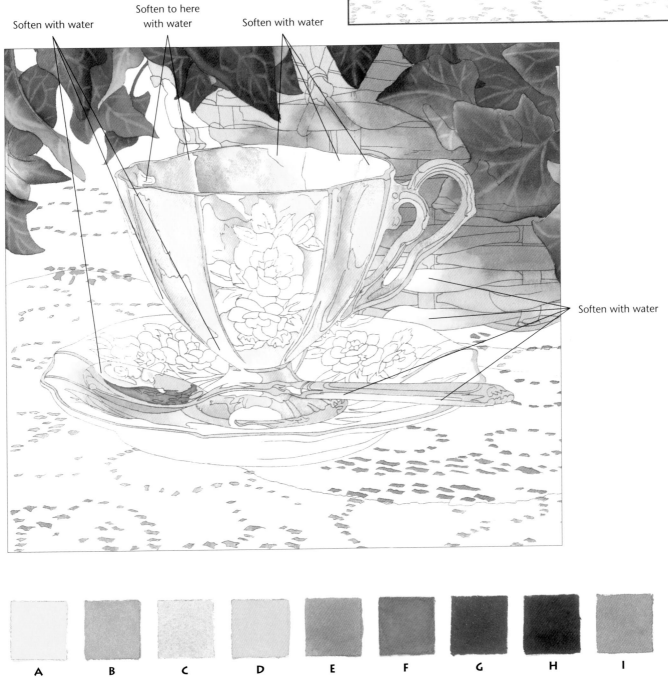

Soften with water

Soften to here
with water

Soften with water

Soften with water

A B C D E F G H I

STEP 2 Paint some shadows and add more color to spoon and basket

1. Paint shadows in the mother-of-pearl areas. Mix colors **B** and **J**. Paint the inside areas of the teacup first, starting on the far left. Load your brush with **J**, and paint a small area. Soften to the line with water. Let dry. Paint the next area, softening to the next line with water. Let dry. Then paint the large area next to that, softening the edge with water, as shown.

Paint the center-front section next, charging in with alternating brushstrokes of water to lighten some of the areas. When the sheen is almost gone, blot the large white rose firmly with a tissue.

Finish painting all the shadow areas on the cup. Let dry. Paint the saucer next, blotting the large white rose firmly with a tissue.

Paint twice the shadow cast on the right side of the saucer, letting the first layer dry completely before painting over it again.

Paint the underside of the saucer next, starting on the right. Load your brush with **J**, and paint along the area below the line, stopping about halfway across. Quickly blot your brush well. Load your brush with **B**, and charge in above the area you just painted with **J**. Soften to the left with water. Let dry.

2. Paint the gold edging on the teacup. Mix colors **E** and **K**. Load your brush that has a nice point with **E**, and paint the two areas shown in the sample. Rinse your brush and blot well. Load your brush with **K**, and paint the rest of the gold areas on the cup and saucer, softening the areas along the saucer's rim with water, as shown. Let dry.

3. Paint the gold spoon. Mix colors **E**, **H**, **K** and **L**. Load your brush that has a nice point with **E**, and paint the underside of the round portion of the spoon. Let dry. Rinse your brush and blot well.

Load your brush with **K**, and paint the areas in the round portion of the spoon, allowing each one to dry before painting the one next to it.

Paint along the lines on the handle next, softening the edges with water, as shown. Rinse your brush and blot well.

Load your brush with **H**, and paint the area inside the round portion of the spoon, charging in with **L**, as shown. Let dry. Rinse your brush and blot well. Load your brush with **H**, and paint the dark green area, carefully painting around the smaller shapes. Let dry.

4. Paint the basket. Mix colors **E**, **H** and **L**. Load your brush with **L**, then touch the tip of your brush into **H**. Paint a wide band of color along the top of a woven section with the **L-H** combination. Rinse your brush and blot well.

Load your brush with **E**, and charge into **L**. Rinse your brush and blot lightly. Soften the rest of the way down with water.

Paint the rest of the basket in the same manner, letting each woven section dry completely before painting the one next to it.

5. Paint the shadows in the leaves. Mix colors **F**, **G** and **H**. Load your brush with **F**, and paint the two light green leaves on the right. Let dry. Rinse your brush and blot well. Load your brush with **H**, and paint those leaves, charging in with **G** and softening some of the edges with water. While the wash is still damp, lift out along the vein lines again, as shown. Let dry.

6. Paint the cast shadow. Mix colors **B** and **M**. Load your brush with **B**, and paint the small area above the end of the spoon. Blot your brush well. Fully load your brush with **M**, then charge **M** into **B**. Continue painting the shadow with **M** as far as the sample shows you to. Blot your brush well. Load your brush with **B**, and charge **B** into **M**. Finish painting the shadow with the **M-B** combination.

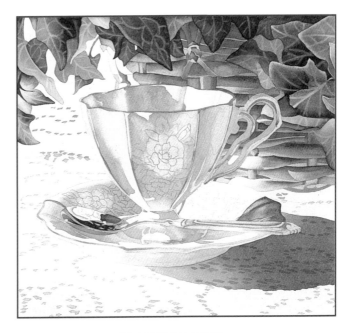

When you are finished with Step Two, your painting will look like this.

Blot firmly with a tissue

Soften upwards with water

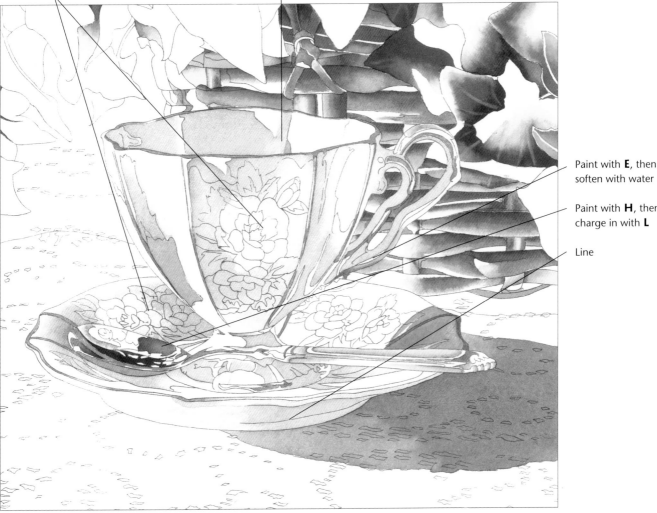

Paint with **E**, then soften with water

Paint with **H**, then charge in with **L**

Line

B

E

F

G

H

J

K

L

M

Paint the roses and final shadows

1. Paint more shadows on the mother-of-pearl areas. Mix colors **J** and **M**. Load your brush with **J**, and paint all the light-colored shadows on the teacup and saucer. Let dry. Rinse your brush and blot well.

Load your brush with **M**, and paint the darker shadows on the teacup handle, the cup's base, and beneath the spoon, softening some of the edges with water, as shown. With **M** still in your brush, paint along the bottom of the saucer, softening above the line with water. When the sheen is almost gone, lift out a long, continuous highlight, as shown in the sample. Let dry.

2. Paint the roses and leaves in the teacup. Mix colors **N, O, P, Q** and **S**. Following Step One, shown at the upper left of the facing page, paint the leaves and petals one at a time, softening with water, as shown. Paint the pink roses with **N**, the white roses with **P**, the blue leaves with **O**, and the green leaves with **Q**.

Paint the leaves' shadows in Step Two with **Q** and **S**. Rinse your brush and blot well between colors. Let each petal and leaf dry completely before painting the one next to it.

When you paint the roses and leaves on the right side of the saucer, blot each petal and leaf firmly with a tissue to lighten the value. Let dry.

3. Paint the shadows in the gold edging. Mix colors **E, H, M** and **Q**. Load your brush that has a nice point with **Q**, and paint along the base of the cup, charging in with **E** and **M** as shown. Paint the rest of the **Q** areas on the teacup and saucer, softening some of the areas with water. Rinse your brush and blot well.

Load your brush with **H**, and paint the small area on the top of the handle, softening the edge with water as shown. Let dry.

4. Paint the shadows in the spoon. Mix colors **E** and **Q**. Load your brush that has a nice point with **E**, and paint the underside of the spoon's handle, as shown in the sample. Rinse your brush and blot well. Load your brush with **Q**, and paint the rest of the areas, softening some of the areas with water as shown. Let dry.

5. Paint the shadows in the basket. Mix colors **E** and **Q**. Load your brush with **Q**, and paint the shadow area at the bottom of the basket as far as shown. Blot your brush well. Load your brush with **E**, and charge **E** into **Q**. Finish painting the shadow with **E**.

Paint the rest of the areas between the woven sections of the basket with **Q**, softening most of the edges with water. Let dry.

6. Paint the background shadow. Mix colors **G, Q** and **M**. Fully load your brush with **Q**, and paint the areas between the leaves at the upper left, softening the one leaf with water. Continue painting downwards with **Q**. Blot your brush well.

Load your brush with **G**, and charge into **Q**. Paint a short distance. Rinse your brush and blot well.

Load your brush with **M**, and charge into **G**. Finish painting the rest of the shadow with **M**, painting over some of the leaf on the left. Soften the edges with water. Let dry.

7. Paint the shadows in the lace holes. Mix colors **I** and **R**. Paint the lace holes in the shadows first. Load your brush that has a nice point with **R**, and paint the entire lace hole again. Paint the lace holes in the cast shadow next. Paint all the holes that have solid shadows first, then paint the lace holes that have partial shadows. Rinse your brush and blot well.

Load your brush with **I**, and paint the shadows in the lace holes that are across the lower front of your painting, leaving a narrow space in each hole. Blot each hole lightly with a tissue. Not all holes have shadows: Paint only the ones shown. Let dry.

TIP

When painting the flowers, stir the puddles that contain Cerulean Blue each time before loading your brush. Otherwise the sediment will settle at the bottom of the puddle, and your brush will just pick up all the sediment.

Roses and Leaves

Step One

Step Two

S

Q

Green-and-blue
leaves

Repeat on all petals

Shadow areas

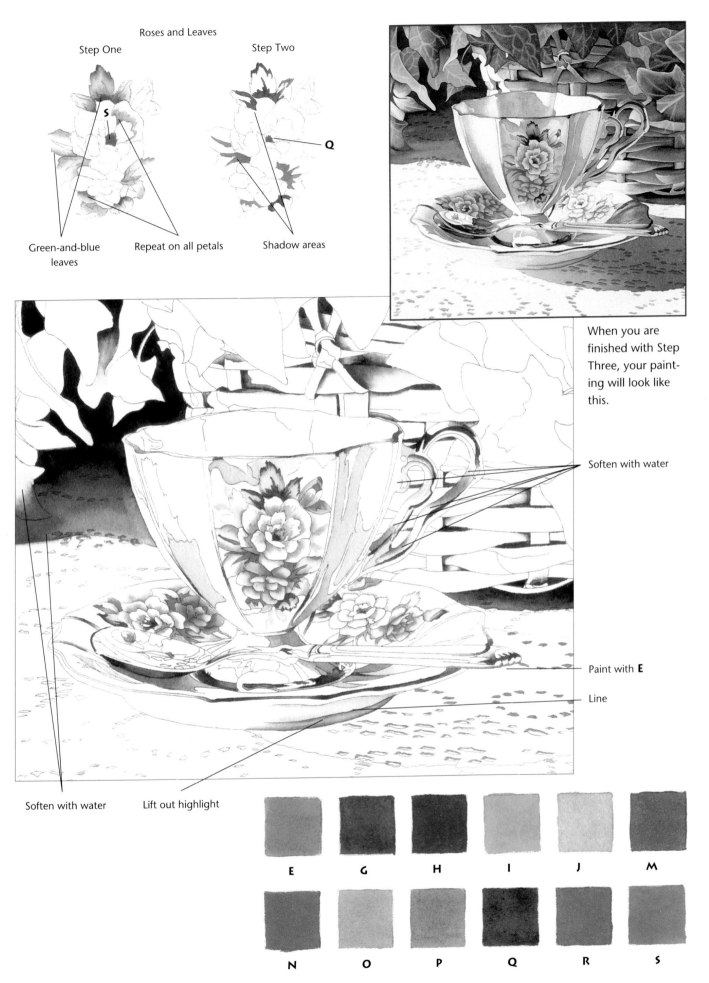

When you are
finished with Step
Three, your paint-
ing will look like
this.

Soften with water

Paint with **E**

Line

Soften with water

Lift out highlight

E G H I J M

N O P Q R S

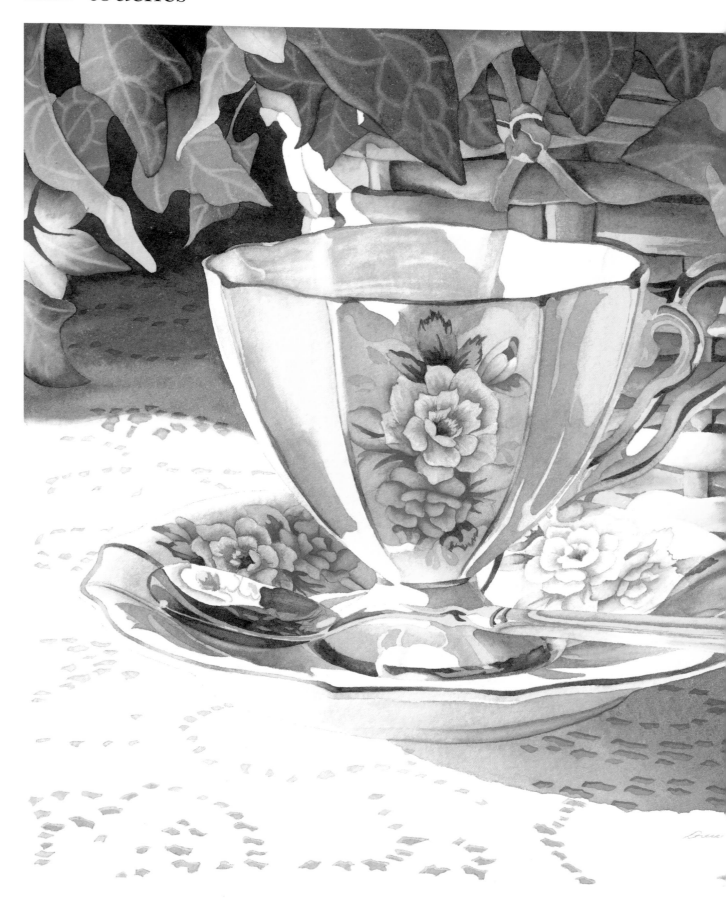

Critique Your Work

Now that you have completed all the steps, compare your painting and its values to the finished painting at left. Take a look at your:

• Teacup and saucer. If you happened to get the shadow on the inside of your teacup too dark, or the streaks that you scrubbed out look too harsh, glaze over the shadow with a light value of Chinese White. Let dry. Repeat until you are pleased with the results.

If your shadow values on the other areas look too light, go back in and deepen them.

If any of the gold areas are too dark, go back in with a clean, moist brush, and lift out some of the color. If the values on your rose patterns are too light, paint them again, but use a lighter value of the color.

• Gold spoon. Darken any areas that you feel need darkening, using a lighter value of that color.

• Basket. If the color on your basket dulled too much, lightly lift off some of the color with a clean, moist brush, and let dry. Then glaze over the woven part again with the Raw Sienna + Carmine color. The areas in between the woven sections are supposed to be really dark. If yours are not very dark, go in and paint them again.

• Ivy. If there is not enough variation of color and value in the leaves, go back and adjust them accordingly. If your leaves dried before you were able to lift out the vein lines, or if you forgot to lift them out, take your scrubby brush and lightly scrub out along the vein lines.

• Cast shadow. If your cast shadow is too light, go over it again with a lighter value, using very light brushstrokes so as not to disturb the color underneath.

If your shadow got too dark, it would be best to leave it alone but offset it by darkening the values in the teacup and basket.

For the spoon, take a clean, moist brush and lightly tickle some of the dark green color over the light green areas in the round portion of the spoon.

Create streaks of reflected light by taking your scrubby brush and lightly scrubbing out some of the color from the inside area of the teacup.

Teacup With a Gold Spoon
Dawn McLeod Heim
Watercolor on Arches 300-lb., cold-press paper
9" x 10" (22.9cm x 25.4cm)

Strawberries and Lace

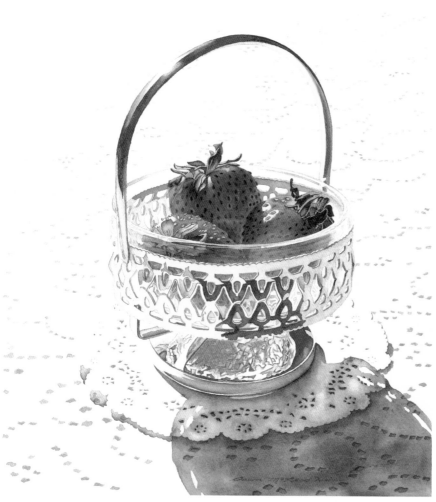

Palette
Yellow Ochre (W&N)
Burnt Umber (W&N)
Perylene Scarlet (D.S.)
French Ultramarine Blue (W&N)
Sap Green (H)
Permanent Rose (W&N)
New Gamboge (W&N)
Alizarin Crimson (W&N)

Brushes
no. 6 round, with a nice point
no. 8 round
1-inch flat
Small scrubby brush
Old brush for applying masking
　fluid

Other
A quarter-sheet (15" h x 11" w or
　38.1cm h x 27.9cm w) Arches
　300-lb., cold-press watercolor
　paper
Masking fluid

In this project, you will be painting a still life with bright morning light pouring in from behind. You will learn what colors you can use to make your strawberries appear lush and ripe in a backlit setting, as well as how to paint an intricate, reflective object such as this silver-and-glass jam server, and make it appear three dimensional. You will also learn how to create depth in a flat object such as this white paper doily lying on an ecru lace tablecloth, by painting just the shadows and the holes.

Color Key
A Yellow Ochre (lt.)
B Burnt Umber + Perylene Scarlet
　(lt./med.)
C French Ultramarine Blue + Sap
　Green + Perylene Scarlet (tad), =
　a grayed blue/green (med.)
D New Gamboge + Permanent Rose +
　French Ultramarine Blue = taupe
　(lt./med.)
E French Ultramarine Blue (lt.)
F Perylene Scarlet (lt./med.)
G Perylene Scarlet + New Gamboge
　(lt./med.)
H Sap Green + New Gamboge (lt.)
I Sap Green + French Ultramarine

Blue (lt./med.)
J Permanent Rose + New Gamboge +
　French Ultramarine Blue = taupe
　(med./dk.)
K French Ultramarine Blue + Alizarin
　Crimson (tad) + New Gamboge
　(tad) = midnight blue (med./dk.)
L Sap Green + French Ultramarine
　Blue + Perylene Scarlet = pine green
　(dk.)
M Alizarin Crimson + French
　Ultramarine Blue (med./dk.)
N Burnt Umber + Perylene Scarlet
　(tad), (dk.)
O Yellow Ochre (dk.)

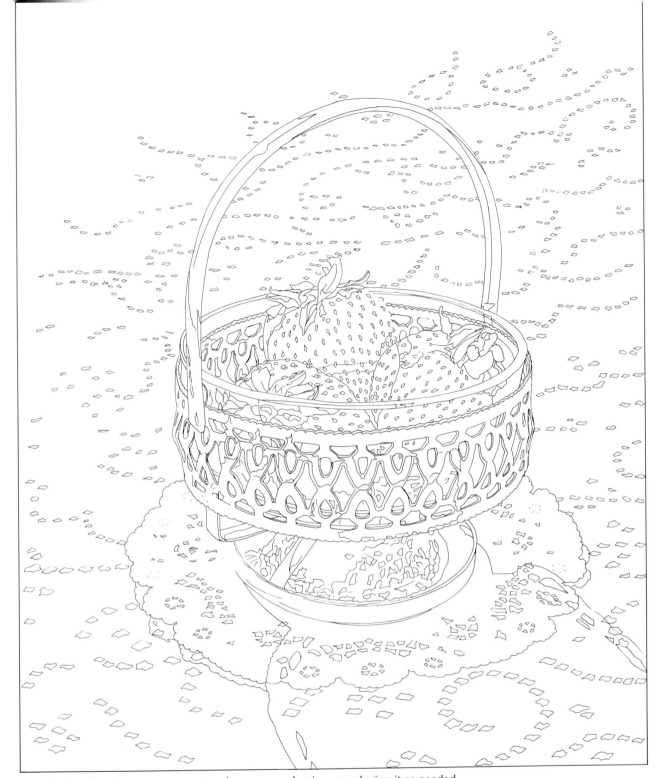

Transfer this drawing onto your watercolor paper, enlarging or reducing it as needed.

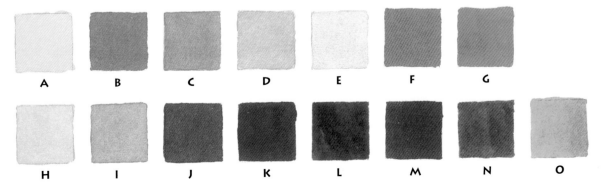

A B C D E F G

H I J K L M N O

STEP 1 Underpainting strawberries, silver, glass and lace

1. Apply masking fluid to the seeds. With an old pointed brush, apply masking fluid to all the white seeds shown in the sample.

2. Paint the lace cloth. Mix color **A**. Lift off any excess graphite from the holes in the cloth. Fully load your 1-inch brush with clean water, and wet the cloth area to the left and right of the silver serving dish. Blot your brush.

Fully load your brush with **A**, and charge into the lower edge of the water on the left side. Paint down the left side of the doily, carefully going around the doily's scalloped edges. Continue painting across the front of the cloth and up the right side, charging **A** into the lower edge of the water on the right side. Take a tissue and randomly blot across the lace cloth. Let dry completely.

3. Apply masking fluid in the cast shadow. Mask out the holes as shown in the sample.

4. Paint the lace holes. Mix color **B**. Load your brush that has a nice point with **B**. Paint the holes, blotting the light value ones firmly with a tissue, and the middle-value ones lightly with a tissue. Do not blot the holes that are in the cast shadow. Let dry.

5. Paint the holes in the doily. Mix color **C**, and paint all the dots and holes, blotting each one lightly with a tissue. Let dry.

6. Paint the intricate band of silver. Mix colors **A** and **D**. Load your brush that has a nice point with **A**, and paint along the top of the narrow, scalloped edge on the front of the silver band. Let dry. Fully load your brush with **A** and, working from left to right, carefully and quickly paint the outside areas on the wide band of silver as far as the sample shows you to. Rinse your brush and blot well.

Quickly load your brush with **D**, and charge **D** into **A**. Finish painting the band with **D**. With **D** still in your brush, paint the back two sections of the band to the left and right of the large strawberry. Let dry.

7. Paint the silver handle. Mix colors **A**, **D**, **E** and **F**. Starting at the top, paint down the left side with **E**, then with **D**. Charge in with **E**, then switch back to **D**. Finish painting the handle with **D**, softening the two areas with water, as shown. Let dry.

Divide the right side of the handle into two sections. Paint the left first with **D**, then charge in with **A**. Finish painting that section with **A**. Let dry.

Paint the section on the right next with **D**, then charge in with **F**. Finish painting that section with **F**. Let dry.

8. Paint the reflections in the silver base. Mix colors **C**, **E** and **G**. Paint the areas on the far left and right first. Paint the small area on the left side with **C**. Rinse your brush and blot well. Load your brush with **E**, paint a few strokes, then soften the edge with water.

Paint the right side with **E** and paint as far as shown. Rinse your brush and blot well. Load your brush with **C**, and charge **C** into **E**.

Finish painting that area with **C**. Lift out a highlight while your wash is still moist. Let dry.

Paint all the **C** areas in the reflection with overlapping brushstrokes, blotting with a tissue to create a textured look. Let dry. Repeat until all the **C** areas in the reflection have been painted. Let dry. Rinse your brush and blot well. Then paint all the **G** areas in the same manner as you did with **C**. Let dry.

9. Paint the glass bowl. Mix colors **C**, **D** and **E**. Paint the lines along the glass rim and all the small areas located between the front sections of the silver band with **C**, **D** and **E**, rinsing and blotting well when changing colors. Let each section dry before painting the one next to it.

10. Paint the leaves. Mix colors **C**, **H** and **I**. Load your brush with **H**, and paint those leaves first. Let dry. Rinse your brush and blot well. Load your brush with **I**, and paint all those leaves, charging **C** into **I** on the left strawberry, and softening some of the edges as shown. Let dry.

11. Paint the strawberries. Mix colors **F**, **G** and **H**. The strawberries are painted twice with **G** and with **F**. Start the strawberry on the right with **H**. Blot your brush well between charging of the colors. Be careful not to paint over the white highlights. Let dry. Next, paint the areas between the intricate silver band. Let dry.

TIP

If you are unsure of your values, keep them on the light side, especially the intricate silver band and the lace holes. You can always go in and paint the area again to deepen the value.

Wet this area Soften with water Highlight area Wet this area

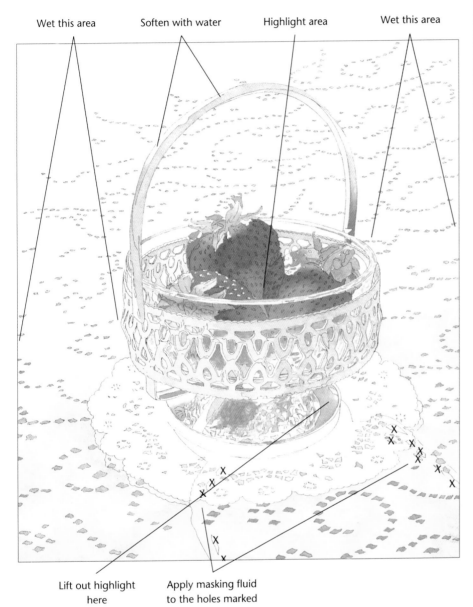

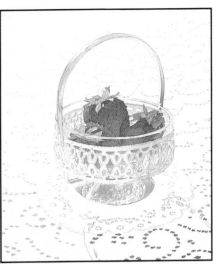

When you are finished with Step One, your painting will look like this.

Lift out highlight here

Apply masking fluid to the holes marked with an X

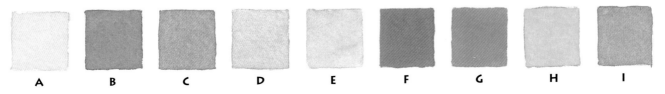

A B C D E F G H I

Paint the cast shadow, and add more color and details

1. Paint the cast shadows, and add more definition to the doily and lace cloth. Mix colors **E** and **J**. Start on the doily at the right of the silver base. Fully load your brush with **J**, and paint a short distance. Take a separate brush loaded with water, and charge into **J**. Paint a small area with the water. Switch back to your brush that's loaded with **J**, and charge **J** into the water. Paint another small area.

Paint the small section in front of the base with **E**. Continue to paint the cast shadow in the same manner, but use less water when painting the lace cloth area. Let dry completely.

Load your brush with **J**, and paint the shadow under the doily on the left side, softening those areas with water. Then paint under the doily in the cast shadow, gently softening all along the edge. Load your brush that has a nice point with **J** and paint the areas along the scalloped edge on the right. Let dry.

2. Paint the areas on the intricate band of silver. Mix colors **C**, **D**, **G**, **J**, **K** and **M**. Load your brush that has a nice point with **J**, and paint along the top of the scalloped edge in the front of the band. Let dry.

Paint along the inside edges of the intricate pattern next, blotting lightly with a tissue the lighter areas on the left side. Rinse your brush and blot well.

Paint the back areas of the silver band to the left and right of the large strawberry with **D**. Let dry.

Paint the rest of the areas across the front of the silver band with **C**, **G**, **J** and **K**, letting each area dry before painting the one next to it. Rinse your brush, and blot well between colors.

Paint the narrow sections toward the bottom of the silver band with **M**. Let dry.

3. Paint the silver handle. Mix colors **F**, **G**, **J** and **K**. Paint the left side along the top with **J** as far as shown. Blot your brush well. Charge **K** into **J**. Continue to paint down the handle, charging in with **G**, then **K**, then **J**, rinsing your brush and blotting well between colors, and softening with water. Let dry.

With **G**, paint down the upper right handle and charge **F** into **G**. Finish painting the handle with **F**. Let dry.

With **J** paint down the center of the area you just painted, gently softening the right edge with water. Let dry.

4. Paint the silver base. Mix colors **C**, **E**, **F**, **J**, **K** and **L**. Paint all the areas in the reflection first. Load your brush with **J** and paint the lines on the far left, the reflection of the support, and the line work on the far right. Let dry. Rinse your brush and blot well. With **L** paint the dark green shapes. Let dry.

With **K**, paint all the dark blue lines and shapes in the center area. Using cross-hatching brushstrokes, paint the orange areas with **F**, blotting each line lightly with a tissue.

Now paint the dark blue reflection on the right. Load your brush with **K**, and paint as far as shown. Blot your brush well. Load your brush with **C**, and charge **C** into **K**. Continue painting to the left along the narrow edge, carefully going around the orange areas. Let dry.

Paint the area of the base that rests on the doily. Start on the right side with **E**. Soften across the middle section with water; charge in with **C**, then soften to the left with clean water. Let dry.

5. Paint the areas in the glass bowl. Mix colors **C**, **F** and **M**. With **C**, paint the leaves located between the intricate silver band in the front. With **F**, paint all the red areas, blotting each one lightly with a tissue. With **M**, paint all the plum-colored areas in the same manner as **F**. Rinse your brush and blot well between colors. Let dry.

6. Paint the shadows in the leaves. Mix colors **I** and **L**. With **I**, paint the three leaves to the left strawberry, softening with water as shown. Rinse your brush and blot well.

With **L**, paint all the rest of the leaves, softening some of the edges with water. Leave a narrow space between the leaves on the strawberry on the right, as shown. Let dry.

7. Paint the shadow color in the strawberries. Mix colors **F** and **M**. Paint the strawberries with **F** and with **M**, using light brushstrokes to gently charge the colors together, and softening the edges with water, as shown.

While your wash is still moist, lift out the highlight across the middle of the back strawberry. Let dry.

TIPS

Make sure you let the orange color dry completely on the right side of the handle before painting down the center with the brown. Otherwise, it will all bleed together.

After you have painted the large cast shadow, try not to go back in and fuss with it. The water that you charge in helps separate the colors and gives beautiful effects. Playing too much with it may spoil the effects. If you need to add more color or fix a certain area, let the shadow completely dry first, then go back in and make your changes.

Cross-hatching

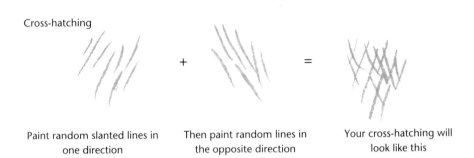

Paint random slanted lines in one direction

+

Then paint random lines in the opposite direction

=

Your cross-hatching will look like this

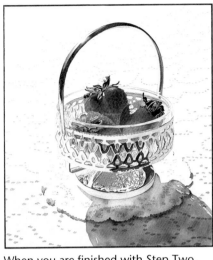

When you are finished with Step Two, your painting will look like this.

Soften with water

Leave a narrow space between each leaf

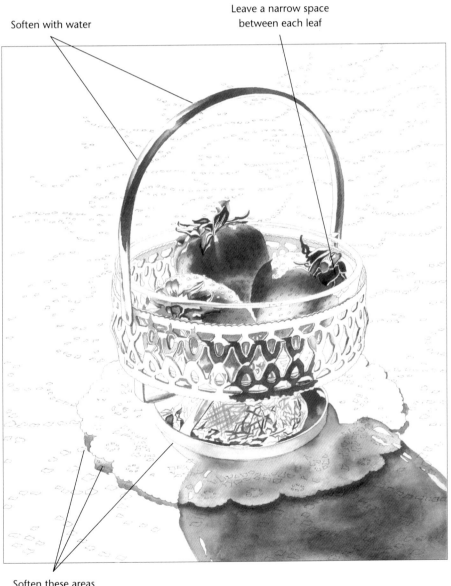

Soften these areas with water

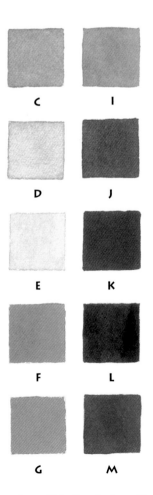

C

I

D

J

E

K

F

L

G

M

STEP 3 Paint the seeds, add more shadows and finish the silver

1. Paint the lace holes and add shadows. Mix colors **B** and **N**. Load your brush that has a nice point with **B**, and paint the lace holes in the back, blotting each one firmly with a tissue. Paint the rest of the lace holes to the left and to the right of the large cast shadow, blotting each one lightly with a tissue. Rinse your brush and blot well. Load your brush with **N**, and paint the shadows on the lace holes in the cast shadow. Let dry.

2. Paint the shadow holes in the doily. Mix colors **J** and **N**. Load your brush that has a nice point with **N**, and paint the holes to the left and right of the cast shadow, leaving a small amount of color **C** visible and blotting each one lightly with a tissue. Paint all the holes in the cast shadow next, but do not blot these holes. Let dry. Load your brush that has a nice point with **J**, and paint the darker shadows in the holes in the cast shadow. Let dry.

3. Paint back sections of the silver band. Mix colors **D**, **F** and **G**. Load your brush with **G**, and paint the left section of the band. Let dry. Rinse your brush and blot well. Paint the right section of the band next. Load your brush with **F**, and paint a short distance. Rinse your brush and blot

well. Load your brush with **D**, and charge **D** into **F**. Finish painting that section with **D**, softening with water as shown. Let dry.

4. Paint the shadows in the silver base and doily. Mix colors **D** and **K**. Paint the silver base first. Load your brush with **K** and, starting on the left, paint a short distance above the line, as shown in the sample. Load a separate brush with **D**, and charge **D** into **K**. Paint with **D** across the front of the base as shown, charging in again with **K** as you near the right side. Let dry.

Paint the shadow on the doily next. Starting on the left side, paint a short distance along the base with your brush that's loaded with **K**. Using your brush that's loaded with **D**, charge **D** into **K**. Soften out that edge with water. Paint another short distance along the base with **K**, charge in with **D**, then soften the edge with water. Repeat until all the shadow has been painted. Let dry.

5. Paint the reflection in the silver base. Mix color **C**. Load your brush with **C**, and paint the solid shapes first. Let dry. Load your brush that has a nice point with **C**, and crosshatch over the large area as shown, blotting each line lightly with a tissue. Let dry.

6. Paint the rim on the glass bowl. Mix colors **L** and **M**. Load your brush that has a nice point with **L**, and paint along the rim as far as shown, softening along the bottom edge. Let dry. Rinse your brush and blot well. Load your brush with **M**, and paint the section next to **L**, softening the middle area with water. Let dry.

7. Paint the seeds. Mix colors **F**, **L**, **N** and **O**. Remove the masking fluid from the seeds. Load your brush that has a nice point with **O**, and paint all the yellow seeds following the directions shown in the sample in the upper left of the facing page. Be careful not to paint over the small, white highlights at the right of the seeds. Paint all the brown seeds with **N** and all the dark- green seeds with **L**. Rinse your brush and blot well between colors.

Blot lightly with a tissue the seeds that are in between the intricate silver band. With **F**, paint the areas around the seeds on the left strawberry, as shown. Repeat the same with **G** on the right strawberry. Let dry.

TIP
Again, remember to keep the holes and lines on the back of the lace cloth as faint as possible to achieve the effect of sunshine pouring in.

Seed Sample for Left Strawberry

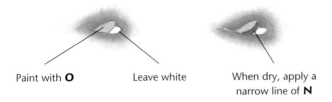

Paint with **O** Leave white When dry, apply a
 narrow line of **N**

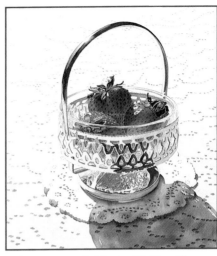

When you are finished with Step Three,
your painting will look like this.

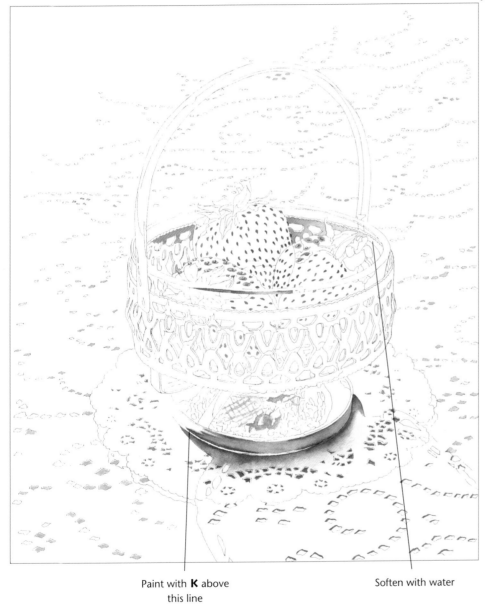

Paint with **K** above
this line

Soften with water

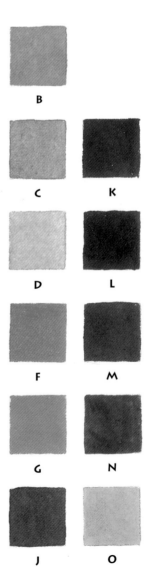

B

C K

D L

F M

G N

J O

Finishing touches

Dip your scrubby brush in water, then, using long brushstrokes, lightly streak the color across the strawberries in the glass area located below the glass rim and above the scalloped edge of the silver band. Do just a few streaks, and do not blot with a tissue. Let dry.

Take a clean, moist brush, and lift out some of the color around some of the seeds from the strawberry in the back and the one on the right.

To achieve a soft, blurred effect from the light on your lace tablecloth, take your scrubby brush that's been dipped in clean water, and lightly scrub out some of the color from the lace holes in the upper left. Blot each hole firmly with your tissue. Use your pickup eraser to remove the masking fluid from the holes in the cast shadow.

Critique Your Work

Now that you have completed all the steps, compare your painting and its values to the finished painting at right. Take a look at your:

• Lace cloth. If the value in your lace holes is too dark, take your scrubby brush, lightly scrub the holes, and blot with a tissue. The holes in the upper left and toward the back should be very light in value.

• Doily. If you accidentally covered too much of the light blue-green color when you painted in with the brown, take your brush that has a nice point, and outline just above the area where the color should be.

If you got too much color on the doily in the cast shadow, lightly scrub out some highlights with your scrubby brush.

• Intricate silver band. Lighten any areas that need to be lightened first by using a clean, moist brush. If the color won't lift, gently and carefully use your scrubby brush.

If the band does not look three-dimensional, or does not appear separate from the glass bowl, go in and outline the inside edges again.

• Silver handle. If you accidentally covered up your highlight at the upper left, lightly scrub out some of the color and blot with a tissue. If the edges on your handle appear jagged or crooked, go back in with that color after blotting your brush on a tissue, and straighten your lines.

• Reflections in the base. Study the finished painting closely and adjust your values accordingly.

• Glass bowl. Look to see whether you have enough blue along the rim and in between the intricate silver band. If not, paint more in.

• Leaves. It would be hard to lighten the value of the leaves. It would be easier to darken the shadow areas again.

• Strawberries. If your strawberries appear muddy and dull after you have painted your shadow color, go over the shadows again with more of the Alizarin Crimson and French Ultramarine Blue, but instead of stroking in the color, lightly bounce your brush and release the color that way. Let dry naturally.

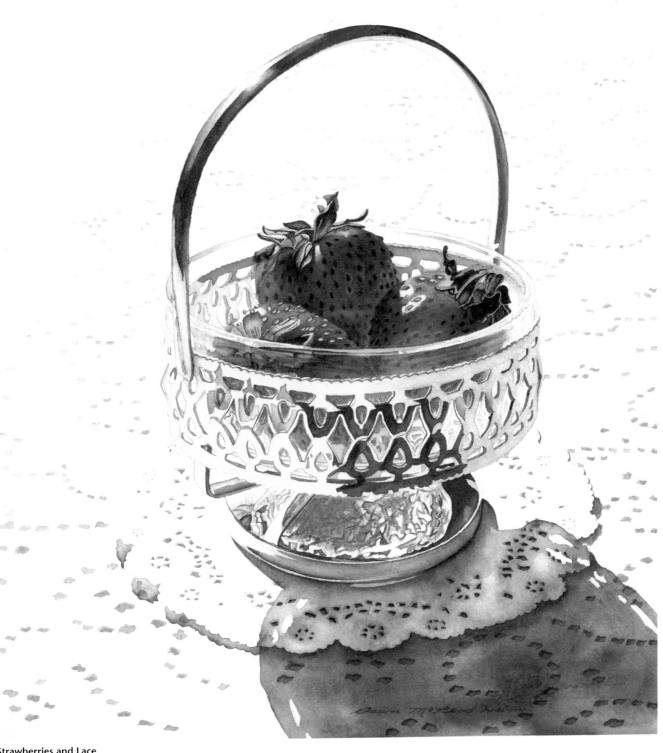

Strawberries and Lace
Dawn McLeod Heim
Watercolor on Arches 300-lb., cold-press paper
11 ½" x 9 ½" (29.2cm x 24.1cm)

Autumn Leaves

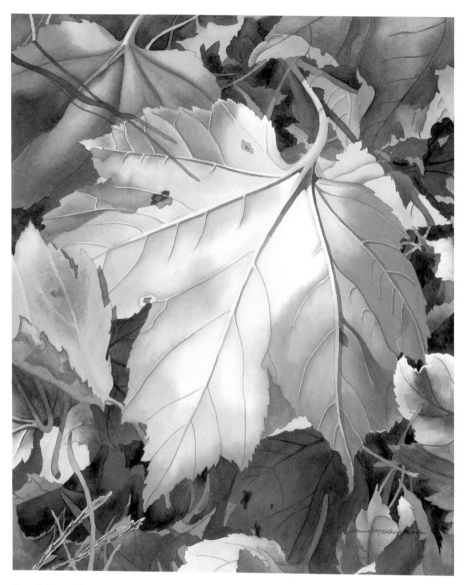

Palette
Sap Green (H)
Winsor Blue (W&N)
Quinacridone Gold (D.S.)
Quinacridone Pink (D.S.)
Quinacridone Sienna (D.S.)
Permanent Brown (D.S.)

Brushes
no. 8 round
no. 10 or no. 12 round

Other
A quarter-sheet (15" h x 11" w or
 38.1cm h x 27.9cm w) Arches 300-
 lb., cold-press watercolor paper

Color Key
A Sap Green (lt./med.)
B Sap Green + Winsor Blue (med.)
C Quinacridone Gold (lt.)
D Quinacridone Pink +
 Quinacridone Sienna (lt./med.)
E Quinacridone Gold (lt./med.)
F Quinacridone Pink +
 Quinacridone Sienna (med./dk.)
G Quinacridone Sienna (med.)
H Permanent Brown (med./dk.)
I Permanent Brown + Sap Green
 (med./dk.)
J Quinacridone Sienna +
 Permanent Brown (med./dk.)
K Permanent Brown + Winsor Blue
 (med./dk.)

In this project, you will learn how to paint these vibrant autumn leaves, using rich, vivid colors and the charging technique. This is a challenging project. Although I have given you ample instructions for the large maple leaf, the dirt and grass, I have limited the amount of instruction for the rest of the leaves. I would like you to paint the rest of the leaves on your own by looking at the sample and using the color squares as a guide for which colors to use.

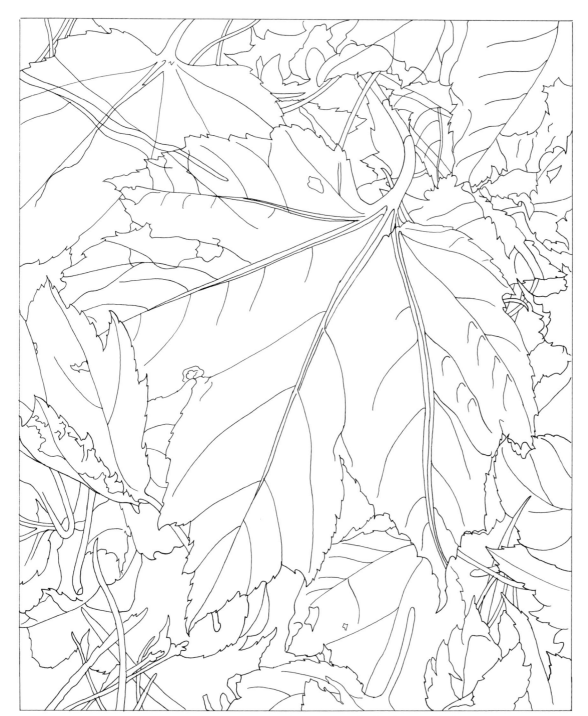

Transfer this drawing onto your watercolor paper, enlarging or reducing it as needed.

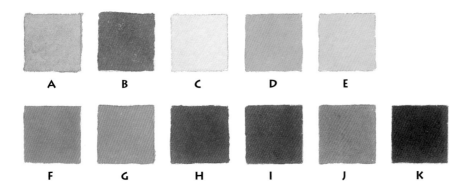

A B C D E

F G H I J K

STEP 1 Paint the grass and dirt, and underpaint the leaves

1. Reinforce the pencil lines. After you have transferred your drawing, go over all the vein and shadow lines again with your pencil. Do not do the large leaf.

2. Paint the grass. Mix colors **A** and **B**. Load your brush with **A**, and paint all the light green grass, letting each blade of grass dry completely before painting the one next to it. Rinse your brush and blot. Load your brush with **B**, and paint all the darker-green grass. Let dry.

3. Paint the large leaf. Mix colors **C** and **D**. Paint the large leaf in sections, using the four large vein lines as dividers. Start with the upper left section. Fully load your brush with **C**; paint down the stem, then up into the left section as shown. Keep moist. Quickly rinse your brush and blot lightly. Apply the water from your brush along the upper left area, as shown. Blot your brush. Fully load your brush with **D**, and charge **D** into the water and into **C**. Paint the pink area, as shown. Continue to paint the rest of that section of the leaf, using alternating charges of **C**, **D** and water. Paint the other sections in the same manner as shown in the sample.

4. Paint the other leaves. Mix colors **C**, **D**, **E**, **F** and **G**. Paint the lighter value leaves first. Load your brush with **D** and paint along the upper area of the pink leaf located to the right of the large leaf's stem. Rinse out your brush and blot lightly. Using light overlapping brushstrokes, charge the water from your brush into **D**. Finish painting the leaf with the lighter value of **D**. Let dry. Paint the rest of the light value leaves in the same manner, using the charging of water method to create the lightest value on that leaf. Refer to the color squares often to help guide you on what colors to use.

When you have finished all the light value leaves, paint the rest of the leaves by following the sample and using the color squares to help guide you. Start with all the single-colored leaves in the sample, letting each one dry completely before painting the one next to it.

Finish painting the rest of the leaves that have two and three colors charged together. Refer to the color squares to help guide you.

5. Paint the dirt. Mix colors **B** and **H**. Load your brush with **H**, and paint a small area, as shown. Take a separate brush that's loaded with **B**, and charge into **H**. Paint a short distance, then charge in with **H** again. Repeat the alternating charging of **B** and **H** on all the dirt areas.

TIP

By now you have experienced two methods of charging: one is by rinsing and blotting well between colors and the other is by just blotting (leaving some of the color still in your brush) between colors.

Both of these methods have been used in these leaves, and both offer great color transition and texture. If this happens to be one of the first projects you have decided to do, or if you are still a little unsure about the charging technique, refer back to pages 25-27 to review this technique. Practice as often as you need to on separate scrap pieces of 300-lb. paper before starting. Be sure to test on the 300-lb. paper, not the 140-lb. paper. The areas you paint on the 140-lb. will dry a lot faster than on the 300-lb., preventing you from getting the charging effects you need.

Remember! You do not need to maintain a bead to charge. Just make sure the area you are charging into is wet. Since the values of the colors you will charge together are within the same value range, you should get some really smooth transitions. It's only when one color is a great deal lighter that you may run into problems.

Start these areas
with clean water,
then paint.

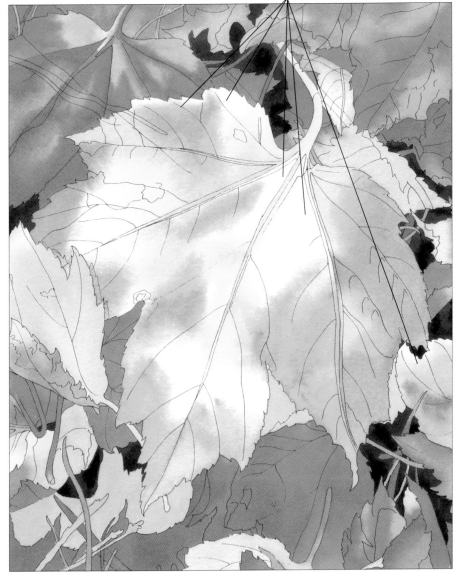

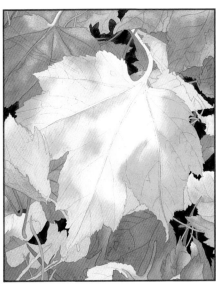

When you are finished with Step One,
your painting will look like this.

A B C D E F G H

Deepen values of the leaves, add shadows and negative veining

1. Negatively vein the large leaf. Mix colors **C**, **D**, **E**, **F** and **G**. Divide the large leaf into sections as you did in Step 1, using the four large vein lines as dividers. Further divide the sections between the large vein lines, creating even smaller vein lines. These are the narrow, white ones in the sample.

Paint a section at a time, charging the colors together as shown. Allow each section to dry completely before painting the one next to it. Match the colors shown in the sample to the color squares and to the color-charging sample at right. A couple of areas have clean water charged in. See sample. Paint the small leaf above the large leaf with **C** and **D**.

2. Paint shadows, and add more color to other leaves. Mix colors **E**, **F**, **G**, **H**, **I**, **J** and **K**. Paint the leaves, matching the colors in the sample to those in the colored squares and the colored charging bars, softening some of the edges with water as shown. Let each leaf section dry completely before painting the one next to it. Since there are so many different shapes of charged colors, I would recommend starting on the upper left leaf and painting each leaf shape as you see it. Continue to paint clockwise, as opposed to jumping around the painting. This way, you will have better control over whether or not you have painted the area.

Colored Charging Bars

Although a few of the leaves show only one color, the majority of them have two or more colors charged together. To help you see which two colors they are, and how you can identify them with the colors in the sample, I have provided you with colored bars showing you how the two colors appear after they have been charged together. I have also provided you with the letter that identifies their color. Let's take, for instance, **K/F**. Load your brush with **K** and paint the area on the leaf that the sample indicates. Blot your brush well. Load your brush with **F** and charge **F** into **K**. Finish painting that area with **F**.

Refer to these bars as often as you need to. Depending on the direction you are painting, the charging can be reversed to read **F/K**.

TIP

When painting a leaf that has more than three colors charged together, I recommend painting the lightest colored area on the leaf first, then quickly charging in with the darker color. Leaves have lots of texture, so there's plenty of room for brushstroke error. For the leaves that have a very dark value, use lighter brushstrokes so as not to disturb some of the texture and charging done in Step One.

When you are finished with Step Two, your painting will look like this.

Paint these three areas first. When the sheen is gone, charge along the vein lines with **F**.

E/J J/F E/J

J/K

K/F

Continue to leave this area the white of the paper.

Wet both of these areas first, then charge in with **I**

J/K G K/J

K/L

K/F

J/E

K/H

J/F

F/G

C D E F G H I J K

STEP 3 Add vein lines to leaves, and final shadows to leaves and grass

1. Paint shadows on grass, and add more color. Mix colors **A** and **B**. Load your brush with **A**, and paint all the blades of grass that are light green, softening some of the areas with water. Rinse your brush and blot well. Load your brush with **B**, and paint all the darker green blades of grass.

2. Paint shadows and dark spots on large leaf. Mix colors **E**, **F**, **J** and **K**. Load your brush with **E** and, starting at the top, paint down the right side of the leaf's stem. Soften the edge with water. Divide the large leaf into sections again, starting at the upper left again.

Load your brush that has a nice point with **E**, and paint along the small vein lines, as shown. Rinse your brush and blot well. Load your brush with **F**, and paint as far as shown. Blot your brush well. Dip the tip of your brush into **E**, and finish painting the small vein line.

Continue alternating the colors as you paint the rest of the shadows along the veins.

Paint the larger shadow sections on the left and right sides with **F**, softening with water, as shown. Some areas have **E** charged in.

When you are finished with the shadows, load your brush with **K**, and paint the dark spots on the leaf, blotting the lighter-value spots with a tissue.

3. Paint shadows and veins to the rest of the leaves. Mix colors **A**, **H**, **I**, **J** and **K**. Paint the rest of the shadows and vein lines on the leaves, matching the colors in the sample to those in the color bar, and softening some of the edges with water, as shown. Again, to avoid confusion, I recommend starting at the upper left and painting clockwise.

TIP

If you get confused as to which color to use when painting the shadows along the vein lines on the large leaf, maybe this will help: Most of the shadow lines on the leaf are just a darker value of the leaf that has already been painted. In other words, if the section of the leaf is the light-gold color, then you would paint the shadow using the darker gold. If the section is an orange color created when you charged the lighter gold into the lighter pink, you would blot your brush that's loaded with the darker gold and place the tip into the darker pink. The darker colors such as **H** and **J** occur mainly toward the top, where the four large veins meet.

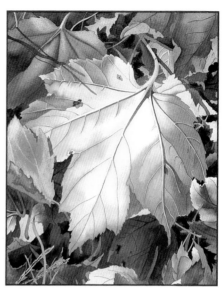

When you are finished with Step Three, your painting will look like this.

Soften with water

Soften along this edge with water

Soften with water

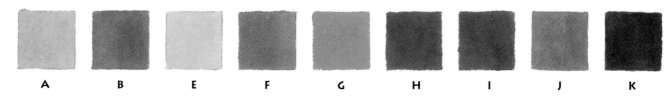

A B E F G H I J K

Finishing touches

Using a clean, moist brush, lightly tickle some of the surrounding color over the veins on the right side of the large leaf.

Critique Your Work

Now that you have completed all the steps, compare your painting and its values to the finished painting at right. Take a look at your:

• Grass. The grass should have both light and dark values. If there is not enough contrast, go back in and darken the darker blades again. Add some light by gently lifting out some of the green with a clean moist brush, then blot with a tissue.

• Large leaf. The focal point of the painting is the white area on the large leaf at the upper right of the center vein. If you lost your white area, go back in and gently scrub out the color. It should lift nearly back to the white of the paper. If the shadows along the vein lines are too light, go back in and darken them.

• The other leaves. Since the large leaf is the focal point, most of the rest of the leaves need to be darker or cooler in value. Glaze over the leaves again if they need setting back. If you lost some of the light areas, take your scrubby brush and lightly scrub out some color, then blot with a tissue. Continue until it matches the light value in the finished painting. If there is not enough contrast between the leaf and the shadow areas, paint the shadow area again—that should help. If you still feel your values are off, look at the finished painting at right and adjust them accordingly.

• Dirt. The areas that represent the dirt should have both the dark green and brown areas visible as well as dark in value. If they need to be darkened, go back in and paint them again.

Autumn Leaves
Dawn McLeod Heim
Watercolor on Arches 300-lb., cold-press paper
12" x 10" (30.5cm x 25.4cm)

Lemons in a Silver Bowl

In this project, you will be painting a subject in a soft, diffused light. You will learn what layers of color you can use to paint this variety of lemon, as well as what techniques to use to create texture in the peel. You will also learn how to make flannel fabric appear soft to the touch using sedimentary colors; how to make striped fabric appear realistically folded and draped; and how to simulate the look of silver with all its reflections of light and color.

Palette
New Gamboge (W&N)
Quinacridone Gold (D.S.)
Winsor Violet (W&N)
Carbazole Violet (D.S.)
Ultramarine Violet (S.H.)
French Ultramarine Blue (W&N)
Burnt Sienna (W&N)
Winsor Red (W&N)
Raw Umber (W&N)
Cadmium Lemon Yellow (W&N)
Sap Green (H)
Sepia (W&N)

Brushes
no. 6 round with a very fine point
no. 8 round
no. 10 or no. 12 round
small scrubby brush

Other
A quarter-sheet (11" h x 15" w or
 27.9cm h x 38.1cm w) Arches 300-
 lb., cold-press watercolor paper
Masking fluid

Transfer this drawing onto your watercolor paper, enlarging or reducing it as needed.

Color Key

A New Gamboge (lt./med.)

B Quinacridone Gold (lt./med.)

C Quinacridone Gold (lt.)

D Winsor Violet (med.)

E Carbazole Violet (med.)

F Ultramarine Violet (med.)

G French Ultramarine Blue (med.)

H Ultramarine Violet + Burnt Sienna + Winsor Red (tad) = warm gray with purple sediment (med.)

I Ultramarine Violet + Burnt Sienna + Winsor Red (tad) = warm gray with purple sediment (lt.)

J Raw Umber + New Gamboge (lt./med.)

K Burnt Sienna + Ultramarine Violet + Winsor Red (tad) = light chocolate brown (med.)

L Winsor Red (lt.)

M Ultramarine Violet + New Gamboge (tad) (lt./med.)

N Cadmium Lemon Yellow (lt./med.)

O Winsor Violet + Sepia (med.)

P Sap Green + Raw Umber (med.)

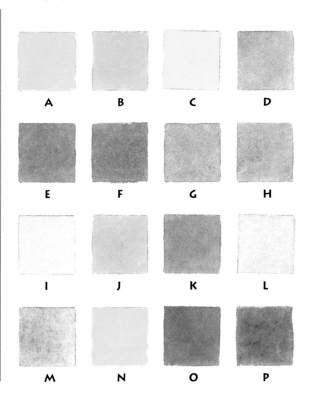

STEP 1 Underpainting color and texture on the lemons, and reflections in the silver

1. Apply masking fluid. Tear off a small piece from a clean, moist, household sponge and dip it into your masking fluid. Squeeze out the excess. With a very light blotting motion, sparingly apply the masking fluid to the right side of the large lemon. Do not apply too much or too heavily; you should barely be able to see it. Let dry completely.

2. Paint the cut lemon. Mix colors **A** and **B**. Paint all the upper segments of the cut lemon first, starting each one with **B**, then charging in with **A**, softening with water in the areas shown. Finish painting the segments with **A**. Let dry. Paint the other segments with **A** and **B**. Let dry.

Load your brush with **B**, and paint the areas on the white peel, charging in with **A** and softening with water, as shown. Let dry.

3. Paint texture on the yellow peel. Mix colors **A** and **B**. Start with the large lemon. Fully load your brush with **A**, and paint a wide band of color down the left side. Rinse your brush and blot well.

Fully load your brush with **B**, and charge **B** into **A**, using overlapping brushstrokes to create a blotchy effect. Rinse your brush and blot well.

Fully load your brush with **A**, and charge **A** into **B**, repeating the same technique. Rinse your brush.

Fully load your brush with clean water, and finish painting the right side of the lemon peel, stopping at the line shown in the sample. Work quickly so that the wash stays moist. Rinse your brush and blot lightly.

When most of the sheen is gone, take your clean, moist brush and go over all the peel, causing the water to push away the pigment. Rinse your brush and blot lightly as many times as you need to get the effect shown in the sample.

Load your brush with **B**, and paint the bottom of the large lemon, softening the edge with water, as shown. Paint the other areas in the yellow peel in the same manner.

4. Paint the reflections in the silver bowl. Mix colors **A**, **B**, **C**, **D**, **E**, **F**, **G** and **H**. Paint all the yellow areas in the silver with **A**, charging in with **B** on the two areas on the right, then softening with water as shown. Let dry. Rinse your brush and blot well.

Paint the stripes' reflections in the silver with **C**, **D**, **E** and **F**, rinsing your brush and blotting well between colors.

Load your brush with **H**, and paint the left section of the silver bowl located under the cut lemon as far as the sample shows you to. Quickly rinse your brush and blot well. Load your brush with **C**, and charge **C** into **H**. Paint as far as shown, softening the edge with water. Let dry.

Next paint with **H** the section to the right under the cut lemon, then charge in **C** as shown. Load your brush with **H** and, starting at the back, paint along the outside rim of the silver as far as the sample shows you to. Rinse your brush and blot well. Load your brush with **G**, and charge **G** into **H**. Paint a few brushstrokes then soften the edge with water. Paint the next blue area, softening the edges with water. Repeat until you reach the scallop in the front, letting each area dry before painting the one next to it. Rinse your brush and blot lightly.

Continue painting along the rim as far as the sample shows you to, using the color from the moist edge and the water left in your brush. Rinse your brush and blot well. Load your brush with **H**, and start painting along the inside areas of the rim, softening along the long edges with water as shown. Let dry.

TIPS

Quinacridone Gold (color **B**) can be a strong color and will dominate your lemons if you let it. Try to keep its value light, and do not overuse; otherwise, your lemons will take on a burnt orange tint. If you feel you have gotten it too dark, lift out some of the color with a clean, moist brush.

Before you load your brush with either **F** or **G**, always restir those puddles. Otherwise, the sediment from the French Ultramarine Blue and the Ultramarine Violet will settle at the bottom. When you load your brush, you'll pick up mostly sediment.

When you are finished with Step One, your painting will look like this.

Soften with water

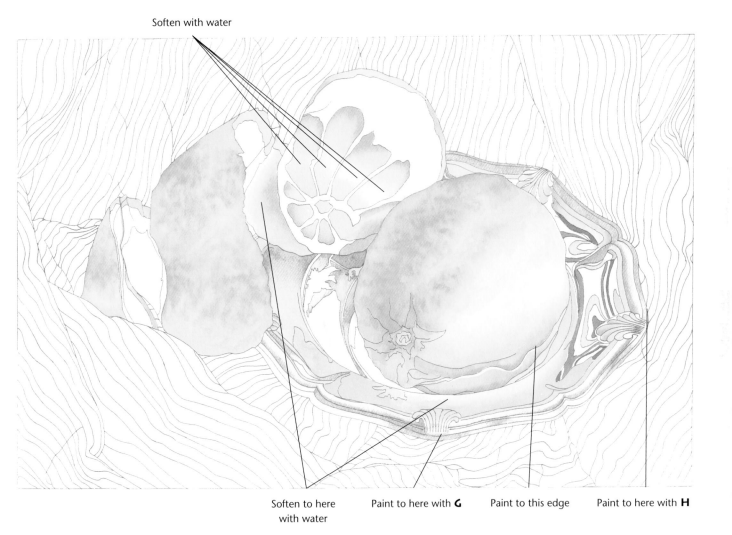

Soften to here
with water

Paint to here with **G**

Paint to this edge

Paint to here with **H**

A B C D E F G H

STEP 2 Paint more texture on the lemons, reflections in the silver and stripes in the fabric

1. Paint the shadows on the white peel. Mix colors **A** and **I**. Start with the inside peel on the far left. Load your brush with **I**, and paint as far as the sample shows you to. Quickly rinse your brush and blot well. Load your brush with **A**, and charge **A** into **I**. Finish painting the shadow with **I**. Repeat the same on the next peel.

Take a brush-load of **I** and a brush-load of water, and make a new puddle. With this lighter value, paint the front section of the cut lemon, softening the upper edge with water, as shown.

2. Paint the yellow peel. Mix colors **A** and **J**. Start with the large lemon. Paint the peel with **A** and **J** following the same technique used in Step One, but place **J** only in the areas shown in the sample at right. Repeat the same steps on the yellow peel of the cut lemon.

3. Paint reflections in the silver bowl. Mix colors **A**, **B**, **H**, **J**, **K**, **L** and **M**. Load your brush with **K**, and paint the shadow in the silver located under the peel of the cut lemon, as far as the sample shows you to, charging in with **H** as shown. Quickly rinse your brush and blot well. Load your brush with **A**, and charge **A** into **H** and **K**. Paint as far as shown, then soften with water. Rinse your brush and blot well.

Paint the reflections in the silver to the right and under the large lemon with alternating charges of **A**, **H**, **J**, **K** and **L**, as shown in the sample. Rinse your brush and blot well. Load your brush with **A** and paint the light yellow along the rim and on the shells. Rinse your brush and blot well.

Load your brush with **B**, and paint the reflection in the silver to the right of the large lemon. Rinse your brush and blot well.

Load your brush with **J**, and paint the reflections along the front of the silver bowl, softening with water, as shown. Rinse your brush and blot well. Load your brush with **M** and paint the two large areas on the right, lifting out three highlights as shown.

4. Paint background stripes. Mix colors **C**, **D**, **E**, **F** and **G**. Start by loading your brush with **C**; then paint all the yellow stripes, blotting lightly with a tissue the lighter areas of each one while you are painting. These yellow stripes will serve as your guide. Rinse your brush and blot well.

Now load your brush with **D**, and paint all those stripes. They are located to the left and to the right of the yellow stripes. Look at the sample showing the stripe pattern.

Now, following the pattern, paint all the **E** stripes. Then all the **F** stripes, and then all of the **G** stripes, blotting all the lighter areas with a tissue, and rinsing your brush and blotting well between colors.

F G F E D C D E F G F

← Stripe Pattern →

When you are finished with Step Two, your painting will look like this.

Leave a narrow white space

Soften with a clean, moist brush

H, **A** and **K**

K

J

J, **H**, **L** and **K**

Soften with water

Lift out highlights

A B C D E F

G H I J K L M

Add more color to the lemons, and paint cool shadows in the fabric

1. Paint the yellow peel. Mix color **N**. Paint the large lemon first. Fully load your brush with **N**, and paint a wide band of color along the left side. Dip your brush into your water container, and slide the excess off the rim. Continue to paint to the right with the lighter value.

Paint the segments in the cut lemon next, softening with water, as shown. Paint the rest of the peel in the same manner, softening with water. Let dry.

2. Paint more reflections in the silver bowl. Mix color **N**. Load your brush with **N**, and paint all the yellow areas along the rim in the silver bowl, softening the edges with water, as shown. Let dry.

3. Paint the background shadows in the fabric. Mix colors **H** and **M**. Starting on the far left, fully load your brush with very clean water, and with light brushstrokes, wet the area around the shadow area that you are about to paint. Fully load your brush with **M**. Using very light brushstrokes, first paint as much of the inside area of the shadow as possible. Then paint outwards toward the water, and allow **M** to charge into the water. This will give you the nice soft edges. A few of the shadows also have **H** in them.

Following the sample, paint the shadows in the fabric in sections, one at a time, allowing each one to dry completely before moving on to the next. Some shadows are supposed to have hard edges; do not prewet them.

Rinse out your brush and blot well. Load your brush with **H** and gently paint the area under the left side of the silver. Blot your brush. Load your brush with **M** and gently finish painting the shadow. Let dry. Repeat the same for the shadow on the right.

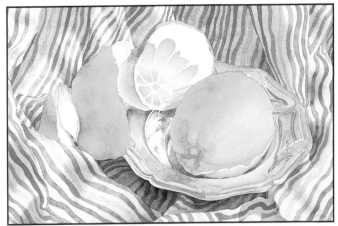

When you are finished with Step Three, your painting will look like this.

Hard edge Soft edge Soften these areas with water

Soften these areas with water Charge in with clean water

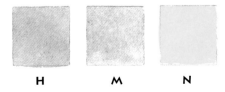

H **M** **N**

STEP 4 Paint the details in lemons, fabric and silver

1. Paint the segments in the cut lemon. Mix color **B**. Load your brush with **B**, and paint the sections in the center area of the cut lemon, softening some of the edges with water, as shown.

2. Paint the details in the silver bowl. Mix colors **B, H, J, M, O** and **P**. Deepen the value of **B, H** and **J** to a medium/dark value. Load your brush with **M**, and paint the areas to the right of the large lemon, softening with water, as shown.

Load your brush that has a nice point with **B**, and paint all the yellow lines, softening some of them with water as shown. Let each line dry completely before painting a new line next to it. Rinse your brush and blot well. Load your brush with **H** and paint all the **H** lines. Rinse your brush blot well.

Load your brush with **O** and, starting at the back of the bowl, paint along the line as shown, stopping at the shell pattern. Quickly

take a clean, moist brush, and soften along the edge. Let dry completely. Now paint along the line directly below that, and quickly soften that edge also. Let dry completely.

Load a brush that has a very nice point with **O** and outline the areas around the shell and also along the lines that divide the sections. Continue to paint the other areas with **O** in the same manner, making sure to let each section dry completely before moving on to the next.

Load your brush with **P**. Paint the reflection on the silver in front of the large lemon as shown, lightly softening the edges with a clean, moist brush.

3. Paint the stem area in the large lemon. Mix colors **O** and **P**. Load your brush with **P**, and paint the inside stem area and the shadow areas on the large lemon, gently softening the edges with water, as shown.

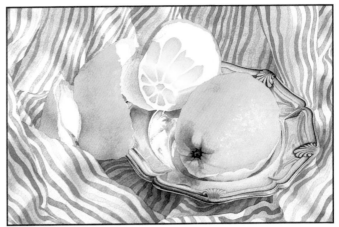

When you are finished with Step Four, your painting will look like this.

Soften with a clean,
moist brush

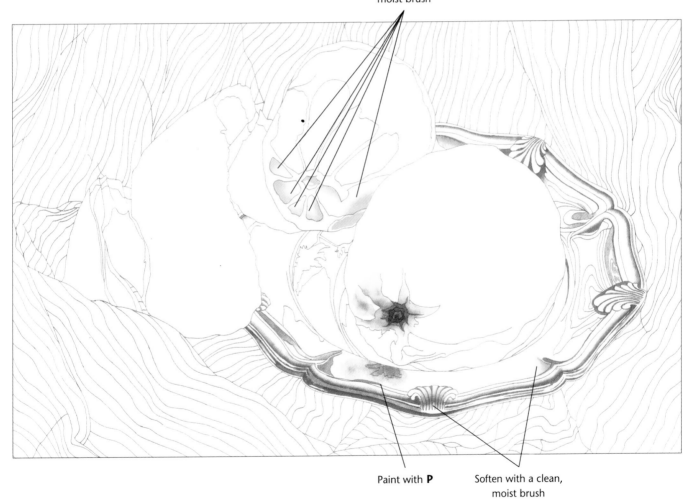

Paint with **P**

Soften with a clean,
moist brush

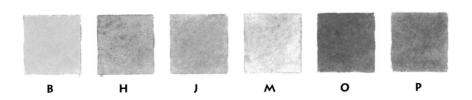

B **H** **J** **M** **O** **P**

STEP 5 Finishing touches

Remove the masking fluid from your large lemon with your pickup eraser.

Critique Your Work

Now that you have completed all the steps, compare your painting and its values to the finished painting at right. Take a look at your:

- Lemons. If you have too much color and texture in your lemon peel, take a clean wet brush and, with firm pressure, go over the areas that have too much color, then blot with a tissue. Continue until you have lifted all the areas that are bothering you. Let dry completely. Then paint over them again with the Cadmium Lemon Yellow and let dry. This should help to punch up the color. If not, go over the areas with the Cadmium Lemon Yellow again.

If you lost all your texture, take your scrubby brush and randomly scrub out some color, blot with a tissue, and let dry. Then go back in with color **J**, add texture where you want it to go, soften the edges. Then paint over them again with **N**.

If your masking marks are too harsh in appearance, take your scrubby brush and water, and lightly tickle some of the hard edges, then blot with a tissue.

- Reflections in silver. If there is not enough definition, go in with some of your darker colors from Step Two and Step Four, and paint some of those areas again. That should help.

If any areas got too dark, try lifting out some of the color first with a moist brush. If that doesn't work, use your scrubby brush, but gently. You still want the silver to look polished, and too much scrubbing will dull it. It may be better just to leave the areas dark.

- Cloth fabric. If there are not enough light areas on your stripes, take a clean, moist brush, and gently tickle some of the color, then blot with a tissue.

If your shadow color got too dark, it's best just to leave it alone. Instead, go back in and darken some of the reflections in the silver to help offset it.

If your shadow color is too light, paint over those areas again in the same manner as you did previously, keeping your brushstrokes light, and use a lighter value.

If you happened to lose the color or the lines from the stripes under the silver bowl in front, paint over the stripes again but with a lighter value.

Lemons in a Silver Bowl
Dawn McLeod Heim
Watercolor on Arches 300-lb., cold-press paper
9" x 14" (22.9cm x 35.6cm)

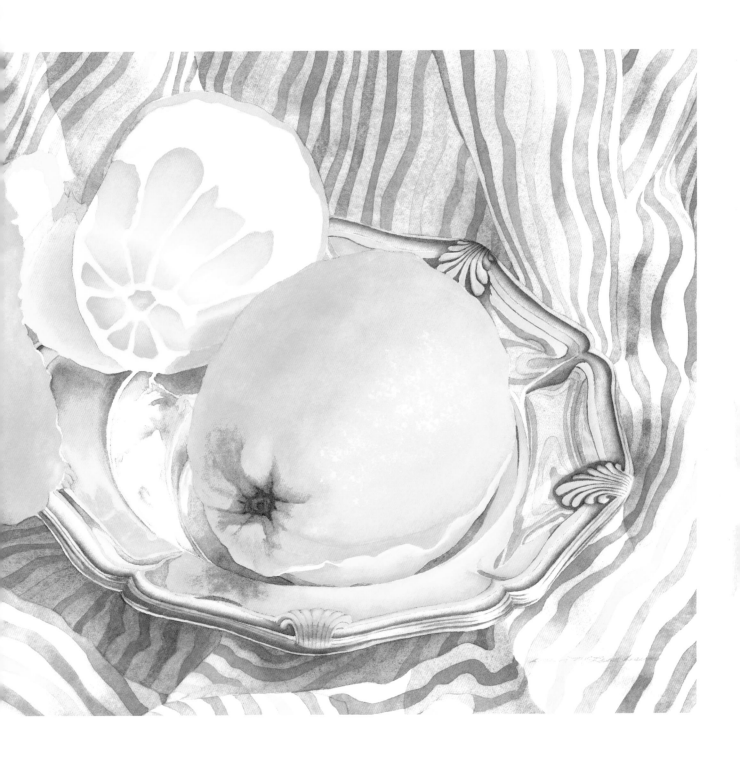

CONCLUSION

I hope you get as much enjoyment out of painting these projects as I did in creating them for you. Mat and frame them and hang them proudly in your home, and then wait for all the compliments you will soon be receiving from your family and friends. Or give them away as gifts to be cherished for a lifetime.

If you are new to watercolor I hope this book made your introduction to this wonderful medium an exciting and rewarding experience. Confidence comes with time and practice, so please be patient with yourself.

If you are already familiar with watercolor, I hope you have gained some insight into painting in layers, learned some new techniques, and enjoyed being introduced to some of the new and wonderful colors now available.

ART SUPPLY SOURCES

Daniel Smith Paints:
 Daniel Smith Inc
 P.O. Box 84268
 Seattle, WA 98124-5568
 Toll-Free (U.S. & Canada):1-800-426-6740

Golden Fleece Brushes:
Extra Palettes:
Lee Fritch Scrub Brushes:
 Cheap Joe's Art Stuff
 374 Industrial Park Drive
 Boone, NC 28607
 Toll-Free (U.S. & Canada): 1-800-227-2788
 Outside U.S. & Canada: 1-704-262-0793

Wax-Free Transfer Paper:
 Saral Paper Co. Inc.
 436-D Central Avenue
 Bohemia, NY 11716

Bette Byrd Brushes:
 Bette Byrd Brushes
 P.O. Box 2526
 Duluth, GA 30136
 1-770-623-6097

San Francisco Slant Palette:
 Brockton Sole & Plastics
 P.O. Box 3750
 Brockton, MA 02404-3750
 1-800-426-4430